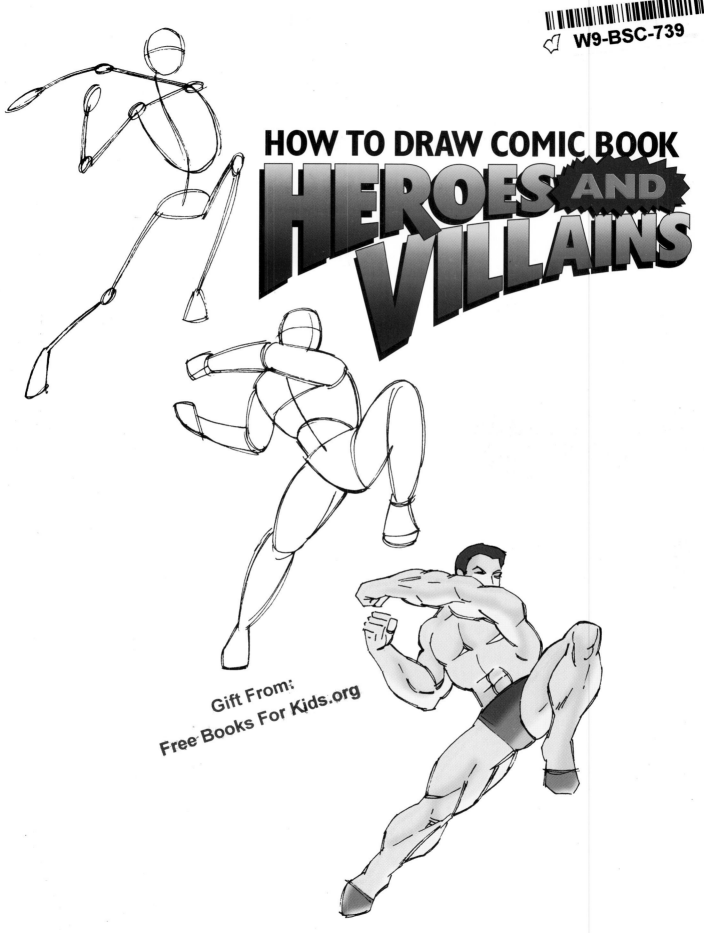

HOW TO DRAW COMIC BOOK
HEROES AND VILLAINS

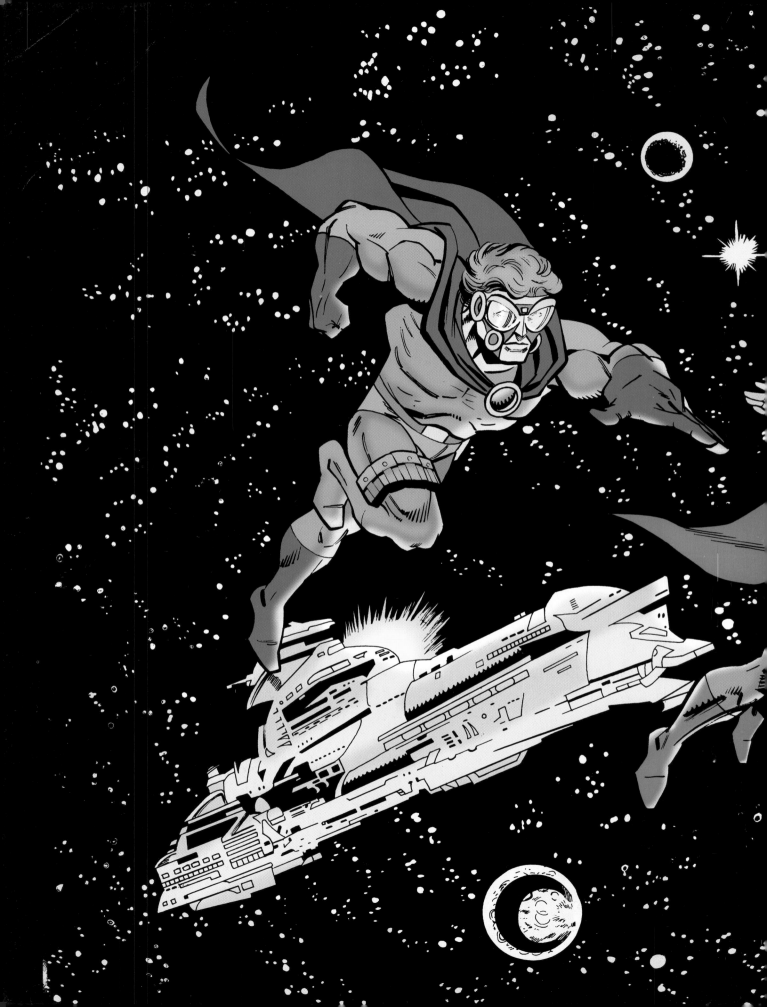

HOW TO DRAW COMIC BOOK
HEROES AND VILLAINS

CHRISTOPHER HART

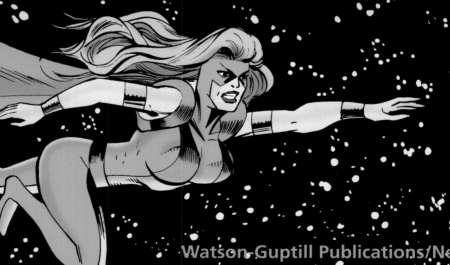

Watson-Guptill Publications/New York

Dedicated to everyone who dreams big

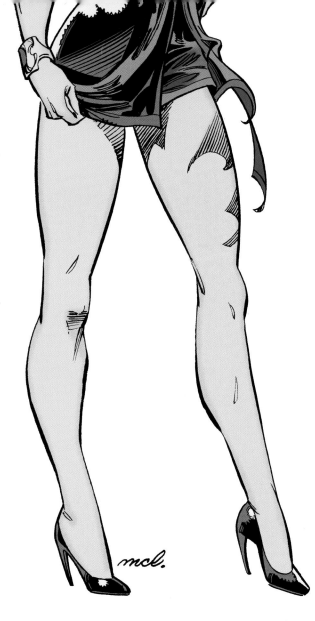

ACKNOWLEDGMENTS

I would like to express my sincere gratitude to Lenny Brown, creative director of the Topps Company, whom I consider to be the maestro of the comics, and without whose help this book might not have been written. Special thanks goes to Jim Salicrup, a former editor of Marvel Comics and now associate publisher and editor-in-chief of Topps Comics, for sharing his time and insights with my readers. Thanks also to Darryl Banks and Rich Faber for their contribution to this book.

A Note to Readers, Parents, and Teachers
Some art materials are unsuitable for young children to use. Children should only use art materials that are labeled as nontoxic and carry the statement "Conforms to ASTM D-4236" or similar wording. All purchase of art materials for and art activities of children under the age of 12 should be supervised by an adult.

Senior Editor: Candace Raney
Edited by Joy Aquilino
Designed by Bob Fillie, Graphiti Graphics
Graphic production by Hector Campbell and Sharon Kaplan
Chapter title art by Carmine Vecchio

First published in 1995 by Watson-Guptill Publications,
a division of BPI Communications, Inc.,
1515 Broadway, New York, N.Y. 10036

Library of Congress Cataloging-in-Publication Data
Hart, Christopher.
 How to draw comic book heroes and villains/Christopher Hart.
 p. cm.
 Includes index.
 Summary: Covers how to create your own original comic book characters, draw fight scenes, design special powers, and invent imaginary creatures, with a section on how the comic business works.
 ISBN 0-8230-2245-5
1. Cartooning—Technique—Juvenile literature. 2. Comic books, strips, etc.—Technique—Juvenile literature. 3. Heroes—Caricatures and cartoons—Juvenile literature. [1. Cartoons and comics. 2. Cartooning—Technique. 3. Drawing—Technique.]
I. Title.
NC1764.H37 1995
741.5—dc20
 95-36859
 CIP
 AC

Manufactured in the United States of America

First printing, 1995

4 5 6 7 8 9 / 03 02 01 00 99 98

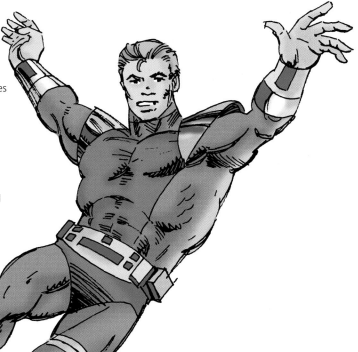

CONTENTS

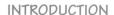

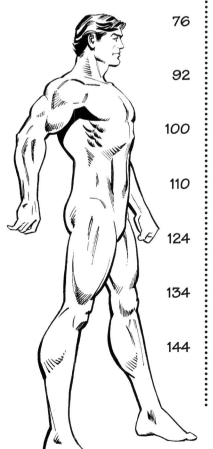

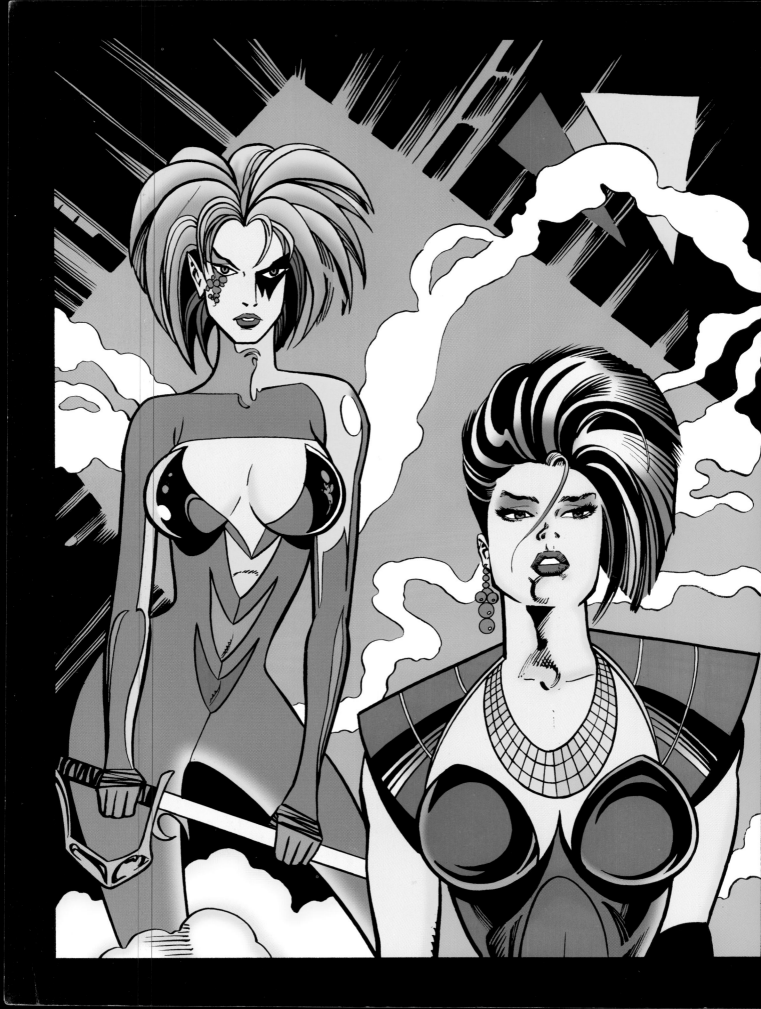

How to Draw Comic Book Heroes and Villains is the ultimate book for anyone aspiring to be a professional comic book illustrator. I'm proud to tell you that these pages feature the work of some of the best talents in the comic book field.

You'll learn from artists who have drawn Superman, Batman, Spider-Man, The Hulk, Conan the Barbarian, The Fantastic Four, The Flash, and Elvira. These pros, who have worked for such notable publishers as Marvel, DC, Valiant, and Defiant, reveal the secrets of designing powerful and convincing fight scenes, drawing heroic anatomy, inventing really bad villains, using special effects techniques, interpreting a script visually, designing advanced weaponry, and much, much more.

Also, there's a chapter devoted to answering the questions that every serious-minded aspiring artist has. You'll learn what to include in a winning portfolio, what the shortcuts are to landing your first job, and how the business really works. For instance, did you know that the person who draws the covers is rarely the same person who draws the interior pages?

This book also features an exclusive interview with Jim Salicrup, the renowned former Marvel editor, and now associate publisher and editor-in-chief of Topps Comics. He shares his insights on the business as he tells you exactly what qualities he and other comic book editors look for when hiring a new artist.

Pencil, paper. And this book. And you're on your way. Dare.

THE CONTRIBUTING ARTISTS

FRANK McLAUGHLIN
Celebrated pen-and-ink artist McLaughlin has 35 years of experience in the comic book industry. Frank has contributed his talents to such famous comic books as Superman, Batman, Wonder Woman, and Green Arrow for DC Comics, as well as Captain America and Iron Fist for Marvel Comics and Femme Fatale for Broadway Comics. He has worked for practically every major comic book publisher, including Valiant, Defiant, Charlton, Seaboard, Dell, and Archie.

GRAY MORROW
Admired and envied for his ability to draw the most gorgeous women in the comic book field, Morrow has created illustrations for Playboy and Penthouse, and also has the distinction of having worked on Batman and Superman for DC Comics. He worked on the animated TV show Spider-Man, the comic strip Tarzan for United Features Syndicate, Power Rangers for Gladstone Comics, and Creepy and Eerie Comics.

FRANK SPRINGER
Well known throughout the industry, Springer is highly regarded for his powerful line drawings. Among his best-known work, Springer drew The Hulk, Conan the Barbarian, The Fantastic Four, Spider-Man, Sgt. Fury, and The Invaders for Marvel, as well as The Flash for DC, Elvira for Claypool Comics, and The Adventures of Hedley Kase for Sports Illustrated Kids.

J. ALEX MORRISSEY
One of the outstanding new artists on the cutting edge of the industry, Morrissey has drawn many Marvel titles, including The Punisher, Ghost Rider, Cloak and Dagger, Cage, Iron Fist, and Power Pack, as well as Division 13 for Dark Horse Comics.

AWESOME *anatomy*

F YOU WANT TO INFLICT MAXIMUM DEVASTATION

on bad guys, then regular anatomy just won't do. You've got to pump up your heroes to awesome proportions. In this chapter, you'll learn exactly how the pros transform ordinary anatomy into super-powered anatomy.

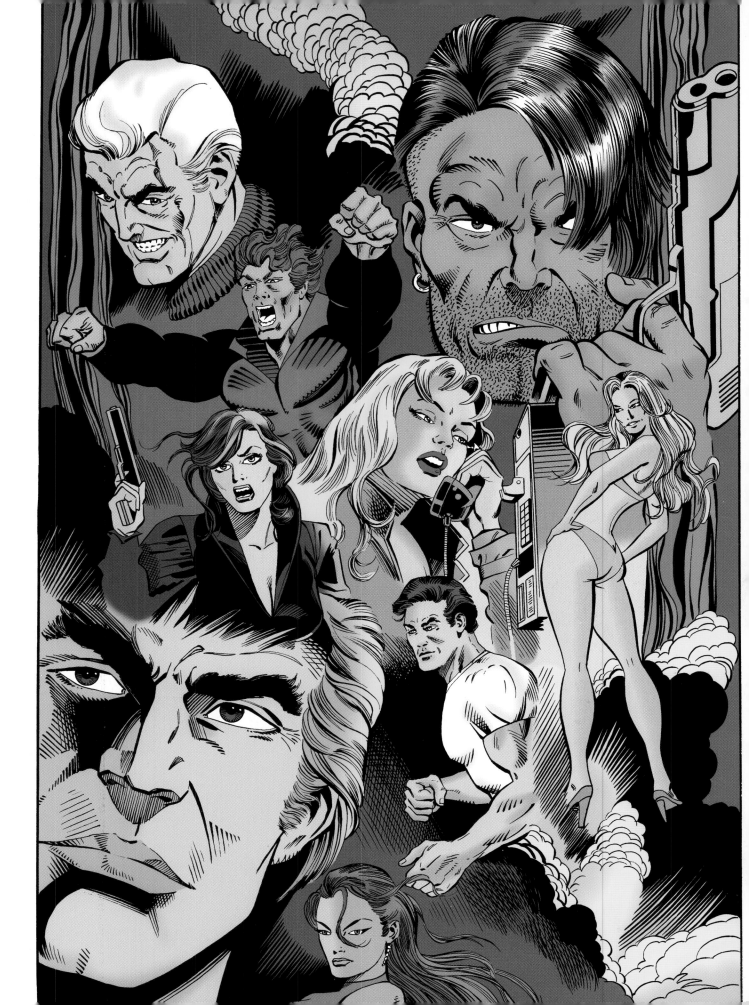

THE CLASSIC HERO'S HEAD

Because professional comic book artists don't always have access to live models, they've created a system for drawing a perfectly proportioned head. The proportions used in this method of drawing the head can be seen in some of the world's most popular comic book heroes.

To make it easier to see how we arrive at these proportions, start by placing the head inside of a rectangle. Then think in terms of halves. Divide the rectangle in half with a horizontal guideline—that's where the eyes go. Place the end of the nose halfway between the eyes and the bottom of the chin. Draw the lips halfway between the end of the nose and the chin.

By drawing guidelines from the center of each eye to the edges of the lips, you get the correct width of the lips. The dotted lines indicate that the eyes are one eye's width apart.

The details, such as wrinkles and hair, are added only after the basic form has been established. If your hero's head doesn't look right, check it against these classic proportions and adjust it accordingly.

FRONT

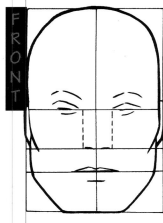
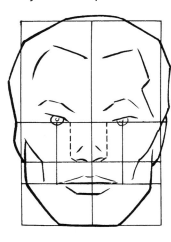
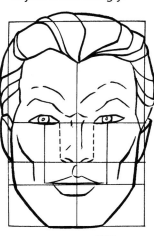

SIDE

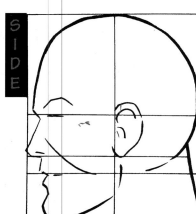
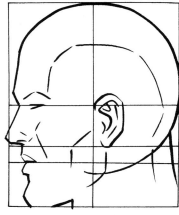
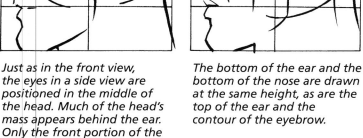

Just as in the front view, the eyes in a side view are positioned in the middle of the head. Much of the head's mass appears behind the ear. Only the front portion of the head makes up the face.

The bottom of the ear and the bottom of the nose are drawn at the same height, as are the top of the ear and the contour of the eyebrow.

The chin should be strong and angular. The neck is thick and muscular.

SKETCHING DIFFERENT HEAD SHAPES

The principal parts of the head are the skull and the jaw. The shape of the skull is a globe—sort of. Actually, it's a globe with the sides lopped off, because the sides of a head aren't perfectly round either.

Extend a line down the center of the face, then make a few marks along that line to indicate where the hairline, the eyes, the bridge of the nose, the mouth, and the chin will go.

By varying the distances among these marks, you can create different characters. Another method for inventing new characters is to change the overall shape of the head.

In every comic book or cartoon illustration of the head, the hairline, eyes, nose, mouth, and chin are drawn on different planes. Keep each feature fixed and locked in its own position and the face will read with clarity.

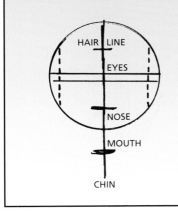

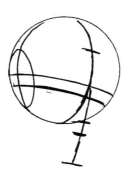
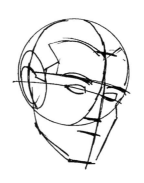
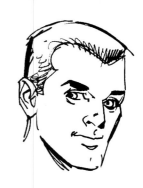

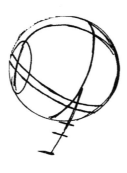
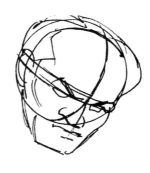

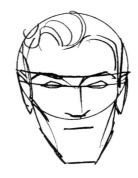
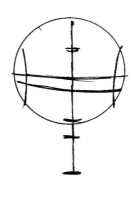
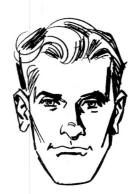

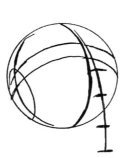
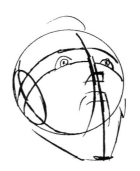
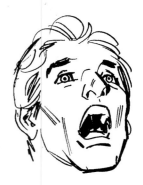

FACIAL FEATURES

MEN'S NOSES AND EARS

As you draw your hero's face, consider the complex angles of his nose and ears. The nose begins at the forehead. About halfway down the nose is a slight indentation—that's where the bone ends and the cartilage begins. Although it isn't always noticeable, it is often indicated in comic book illustration because it gives a dramatic look. Pay close attention to the planes of the nose—top, sides, and bottom.

If you look closely at the interior of the ear (below, right), you'll notice a tilted Y shape. Use this shape when drawing your hero in profile.

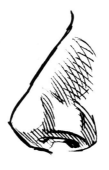 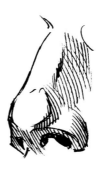 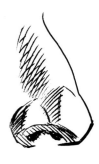

The ears and the nose are the only two parts of the body that never stop growing. Therefore, when drawing an older character, make his nose and ears larger than normal.

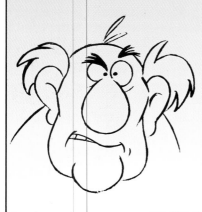

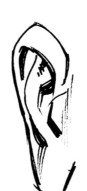 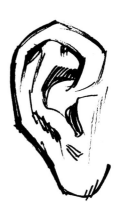

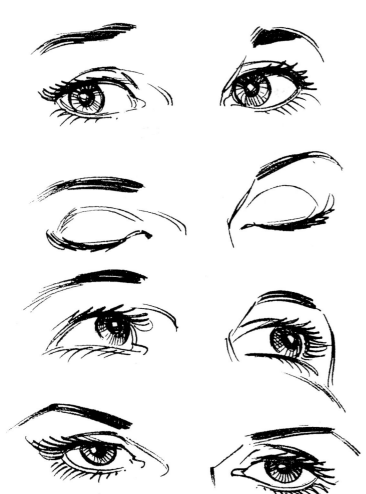

WOMEN'S LIPS

Female characters are always drawn with full lips, which gives them a pensive, moody quality. The bottom lip is usually fuller than the top one. The lips stretch horizontally around the surface of the face, so it's important to draw them as if they were wrapping around a cylinder. Do not draw the lips as straight lines.

To show gleaming, bright teeth, draw the shadows between them. (The shadows should become thinner toward the front of the mouth.) Use more shadows at the edges of the mouth to give the teeth the illusion of roundness. Unless you're trying to draw an angry, frightened, or otherwise severe expression, don't draw each individual tooth.

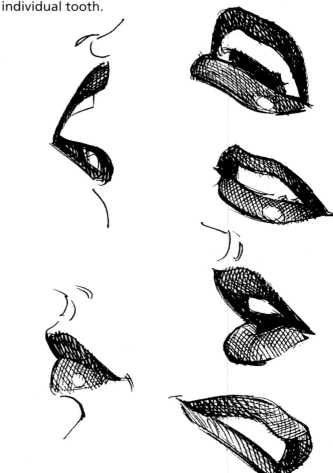

WOMEN'S EYES

Breathtaking eyes increase the appeal of any female character, whether she's a good gal or a bad one. Keep in mind that the eyeball is first drawn round, not almond-shaped—it's the way the eyelid is attached to the eye that makes it look oval. The eyelid acts as a hood, creating a shadow along the top of the eyeball. The lashes on both lids become progressively thicker and darker as you work toward the eye's outer corner, though the bottom lashes are somewhat shorter.

To make the eyeball appear wet, add a highlight of white to the iris. If the highlight is too big, it will make your character look like she's staring, which will also happen if you show too much eyeball and not enough eyelid. You want to show one-third eyelid to two-thirds eyeball.

Get as much expression into the eyebrows as you possibly can. They are the key to conveying emotion. Unless a person is squinting or stunned, the shape of the eye doesn't change as dramatically as the eyebrows, which can be raised, lowered, furrowed, or arched.

HOW TO DRAW HAIR

Your own hair doesn't look like a hat—why should your character's? First draw the head *without* hair, then decide what the hair style should be. Lines for hair should flow *away* from the scalp and continue in the direction(s) set by the particular style.

Instead of trying to draw each individual hair, draw large shapes and tufts. Don't make the hair appear too uniform.

For women, especially blondes, you can create the illusion of luster by bunching some black lines together, provided that these lines also flow in the same direction as the hair.

MEN'S HAIR STYLES

Your character can get pulverized in a fight scene, thrown through an exploding building, and dumped in a toxic waste dump, but his hair's still gotta look good. What's more, you've got to make sure that your hero's hair style stays the same throughout the course of his career. Occasionally, a comic book's editorial staff will decide to change or update a character's appearance, in which case the entire character, including his costume, is reevaluated. Notice how this character's careless hairstyle (left) is actually well plotted. Shown on the opposite page are some standard types. You can make up your own, or combine the features of several.

WOMEN'S HAIR STYLES

There's a wide range of hair styles for women, far more than for men. The one you choose for your character should complement and harmonize with her appearance. A woman's hair is drawn with longer, more flowing strokes than a man's. Notice how the hair cascades off the shoulders (left). Notice, too, how the hairline starts higher on the female forehead, emphasizing its roundness.

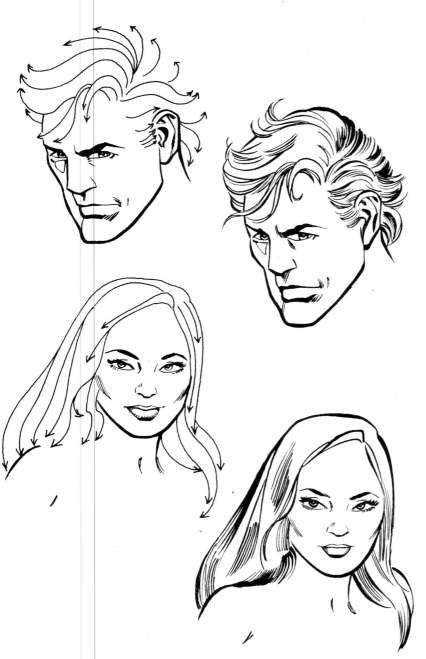

DON'T
outline the hair like a hat—it's not a helmet!

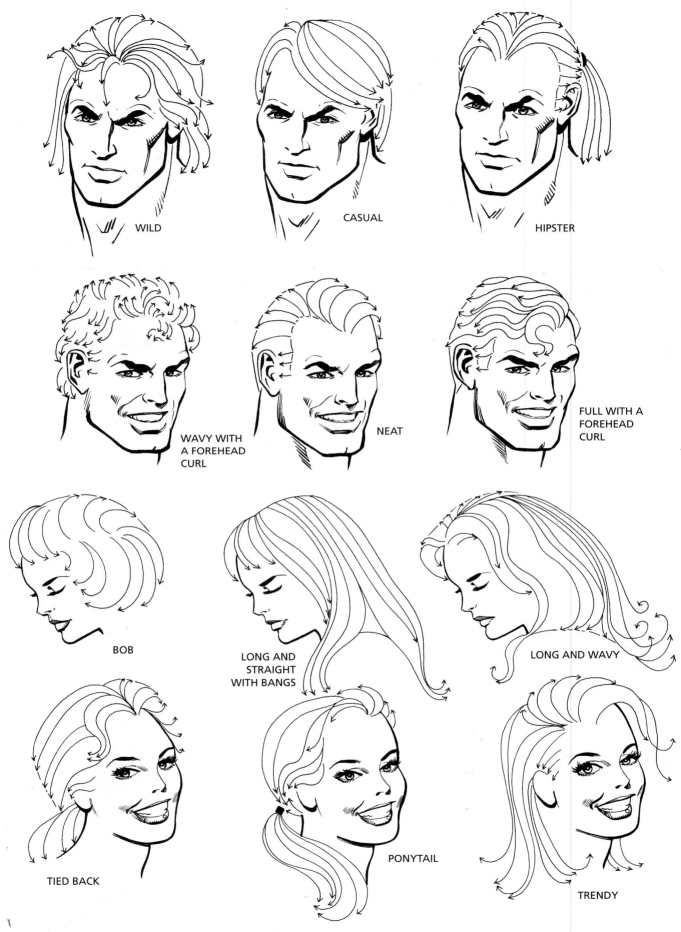

WILD

CASUAL

HIPSTER

WAVY WITH
A FOREHEAD
CURL

NEAT

FULL WITH A
FOREHEAD
CURL

BOB

LONG AND
STRAIGHT
WITH BANGS

LONG AND WAVY

TIED BACK

PONYTAIL

TRENDY

POPULAR COMIC BOOK EXPRESSIONS

There are as many facial expressions as there are faces, but some are better suited to comic book illustration than others. You could draw a guy with his eyes popping out and his jaw on the floor, but chances are you'd be better off working in an animation studio—or locked away where you wouldn't be a danger to yourself or others. Draw only the lines that actually create the expression. The width of the jaw will vary, depending on whether the character is clenching his teeth.

DISDAIN (ANNOYANCE)
Eyebrows curve downward, then level off. The line of the mouth is small and taut. The jaw is wide because the teeth are clenched.

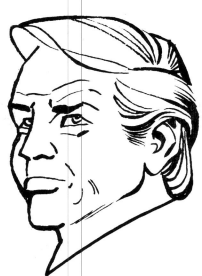

SURPRISE
Lines on the forehead repeat the shape of the eyebrows, which are severely arched. The face elongates as the mouth opens.

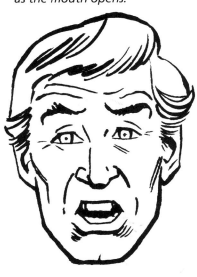

RAGE
Eyebrows plunge dramatically downward, then flare out at the edges. The teeth are clenched and visible; nostrils are flared.

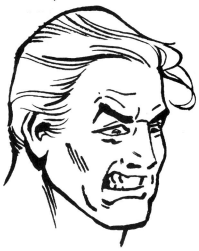

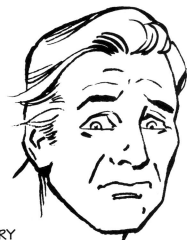

WORRY
Eyes are widened, eyebrows are slanted upward, and the brow is furrowed.

DETERMINATION
The jaw juts forward, the lips tighten, nostrils flare, and the eyebrows slope downward toward the bridge of the nose, creating a crease in the forehead. The face narrows, emphasizing the cheekbones.

Because they express a variety of intense emotions, grimaces are popular comic book facial expressions. A grimace can convey a fighting mood, a solemn moment, or fury. The characteristic traits of the grimace are intense, down-turned eyebrows, down-turned mouth, accentuated cheekbones, and tousled hair. Below are several types of grimaces, both open- and close-mouthed, shown from various angles.

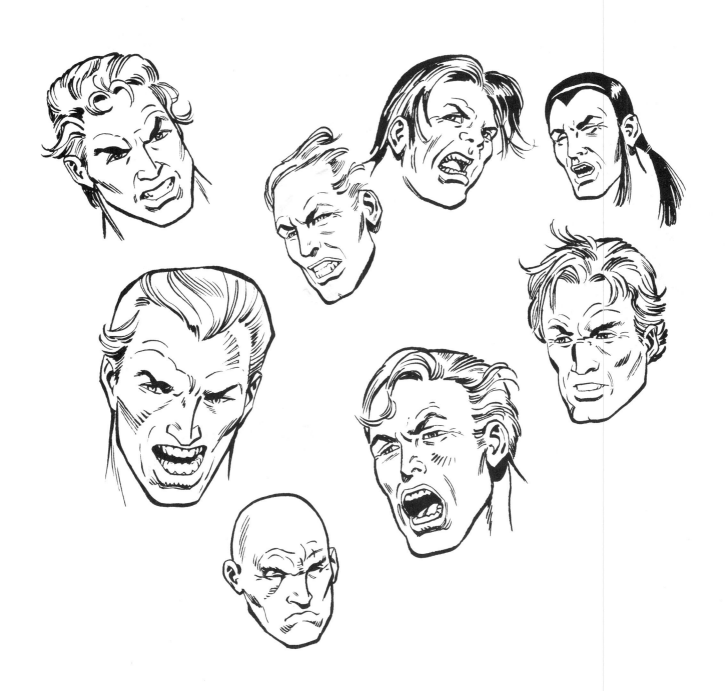

ANATOMICAL PROPORTIONS

When drawing a figure, the head is used as the basic unit of measurement. According to some authorities, the average person is 6½ heads high, while other artists use a standard height of 7½ heads.

The proportions of comic book heroes are extremely exaggerated. These figures are typically drawn 8 heads high. The smaller the head, the more powerful the body will appear in contrast.

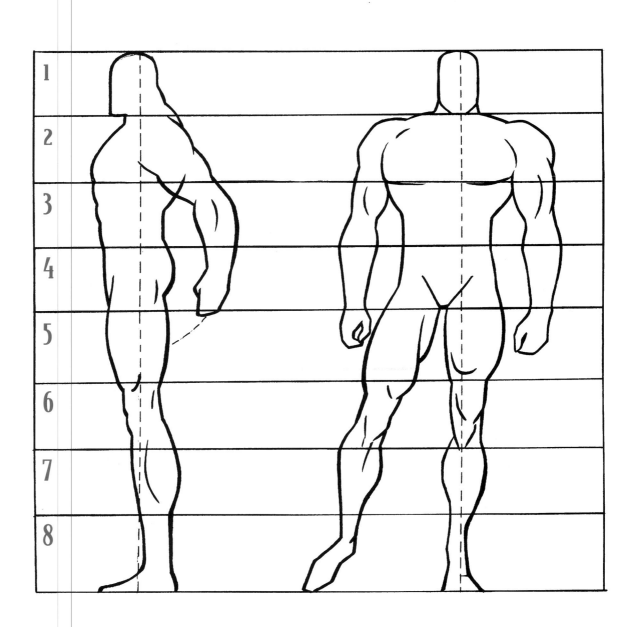

This guy is 9 heads high—positively huge. These proportions make the figure look massive and unreal—desirable qualities for a comic book hero. Some brutes have been drawn as much as 15 or even 20 heads high, which are highly stylized proportions.

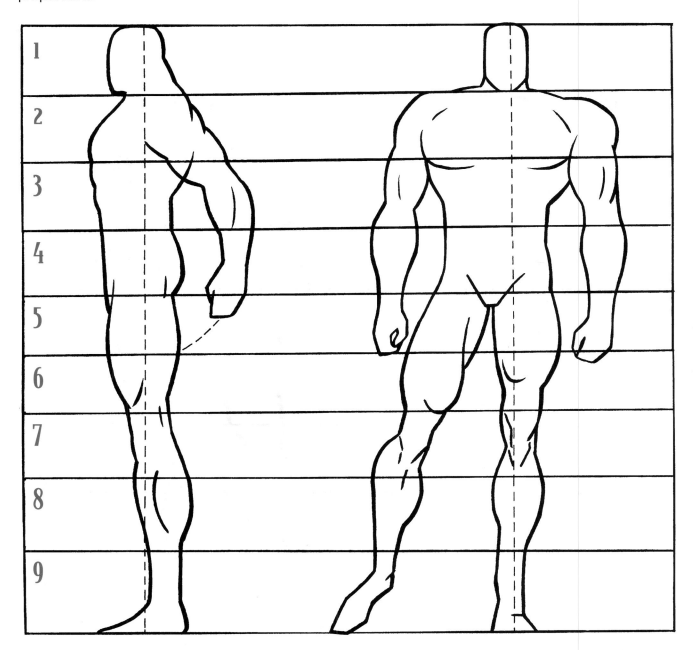

BODY BASICS

Look at the basic lines of the body. All its forces are working in harmony. The thick, black lines indicate the position of the major bones, which serve as the foundation for every pose. You can see the weight and mass of the rib cage, the curve and direction of the spine, and the width of the pelvis.

Note that the collarbone is wide, like a ledge, which lays the foundation for a massive chest. The shoulder blades add width to the back. This visual shorthand provides the framework on which the finished drawing is hung. All of your figure drawings should begin with this underlying framework.

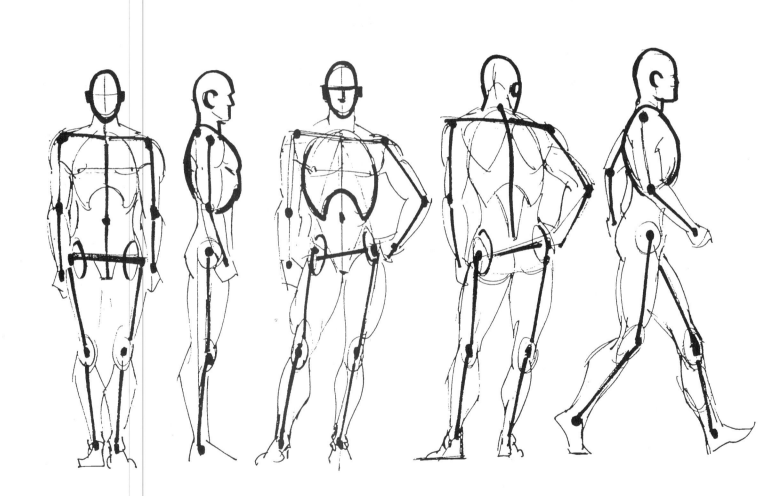

BUILDING AN ACTION POSE

Comic book heroes and villains are made to move, jump, leap, and soar. But when you start to position your figure in dynamic poses, things can get tricky—unless you've taken care to maintain its essential building blocks. This is done by taking a moment to sketch out a solid rib cage, collar bone, pelvis, and the other major bones before executing the finished drawing.

Contrary to what your instincts might tell you, muscles alone do not make a character appear sturdy. Solid bone structure does. That's because all muscles are attached to bones, so unless you have a solid foundation of bones, those muscles will appear rubbery. But that doesn't mean that you must render a skeleton in painstaking detail. It can be done quickly, in a sketchy shorthand, as in these fine examples. While it's true that you'll erase many of these preliminary steps when you do the final "clean" version of your hero, your drawings will benefit immeasurably from them.

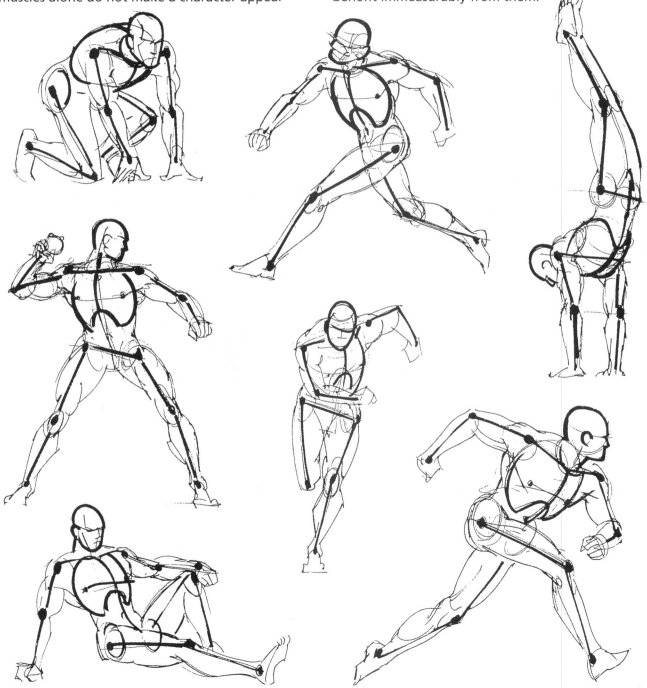

THE ACTION FIGURE, STEP BY STEP

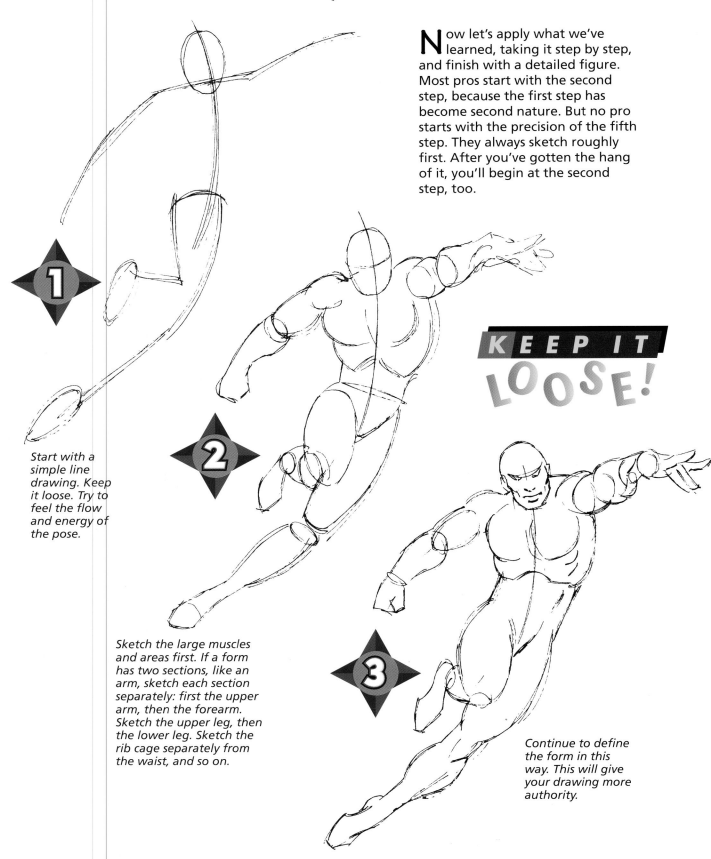

Now let's apply what we've learned, taking it step by step, and finish with a detailed figure. Most pros start with the second step, because the first step has become second nature. But no pro starts with the precision of the fifth step. They always sketch roughly first. After you've gotten the hang of it, you'll begin at the second step, too.

KEEP IT LOOSE!

Start with a simple line drawing. Keep it loose. Try to feel the flow and energy of the pose.

Sketch the large muscles and areas first. If a form has two sections, like an arm, sketch each section separately: first the upper arm, then the forearm. Sketch the upper leg, then the lower leg. Sketch the rib cage separately from the waist, and so on.

Continue to define the form in this way. This will give your drawing more authority.

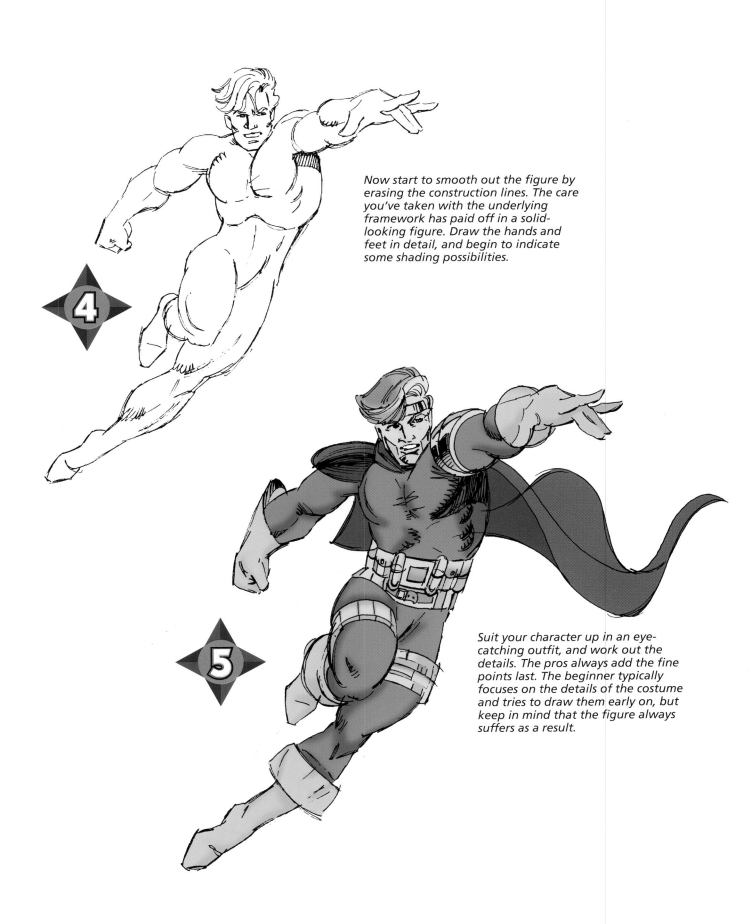

4

Now start to smooth out the figure by erasing the construction lines. The care you've taken with the underlying framework has paid off in a solid-looking figure. Draw the hands and feet in detail, and begin to indicate some shading possibilities.

5

Suit your character up in an eye-catching outfit, and work out the details. The pros always add the fine points last. The beginner typically focuses on the details of the costume and tries to draw them early on, but keep in mind that the figure always suffers as a result.

THE HEROIC FEMALE FIGURE

The heroic female figure has a fairly wide collarbone, resulting in square, well-muscled shoulders. A woman's rib cage, bones, and all of her muscles are smaller than a man's. Her torso tapers sharply at the waist, but her pelvis is wider. As a rule, comic book women are drawn with more curves, while the men are drawn with more heavy angles.

For detailed information on how to draw comic book heroines, see "Beautiful But Deadly," pages 56–75.

BODY LINES

The *center of balance* is an imaginary vertical line drawn through the body. Half of the body's weight is on either side of the line, which maintains the body's balance. If the weight isn't distributed evenly, the figure will fall down, bang her head, and sue. You don't want that.

Sometimes, though, it's okay, even necessary, to draw a character with his or her weight off balance. Can you think of an example? How about when a character is in motion? The act of walking is, in reality, a process of falling and catching yourself. If you were always in perfect balance you wouldn't be able to walk, because you couldn't transfer your weight from one foot to the other.

There are shoulder and hip lines to be aware of, too. This means that as one shoulder dips, the hip on that side of the body rises to compensate. Also, each time a limb or body mass extends past the center of balance, there must be an equal and opposite movement on the other side of the figure so that its balance is maintained.

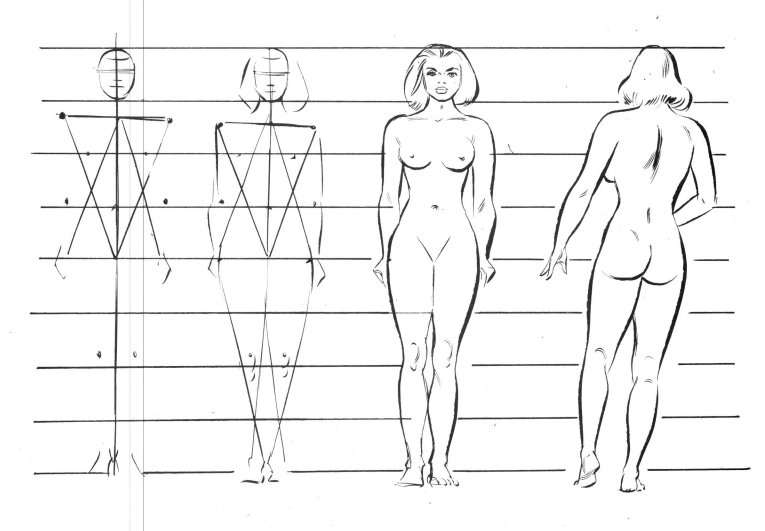

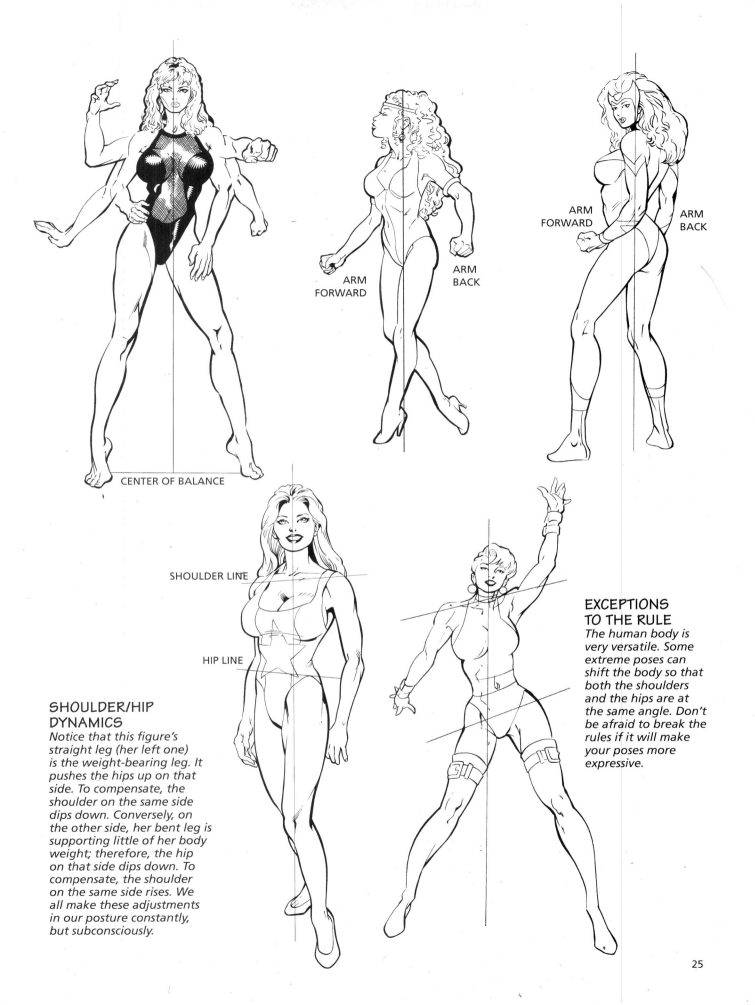

CENTER OF BALANCE

ARM
FORWARD

ARM
BACK

ARM
FORWARD

ARM
BACK

SHOULDER LINE

HIP LINE

SHOULDER/HIP DYNAMICS

Notice that this figure's straight leg (her left one) is the weight-bearing leg. It pushes the hips up on that side. To compensate, the shoulder on the same side dips down. Conversely, on the other side, her bent leg is supporting little of her body weight; therefore, the hip on that side dips down. To compensate, the shoulder on the same side rises. We all make these adjustments in our posture constantly, but subconsciously.

EXCEPTIONS TO THE RULE

The human body is very versatile. Some extreme poses can shift the body so that both the shoulders and the hips are at the same angle. Don't be afraid to break the rules if it will make your poses more expressive.

ANATOMY OF THE HAND

Many beginning artists try to copy the dramatic hand poses of the pros without first taking a look at the basic construction of the hand. Don't make the mistake of guessing on this important anatomical feature. I can evaluate the caliber of an artist by his or her ability to draw hands—and so can everyone else.

Each finger has three distinct joints that are marked with creases on both sides of the hand. Even on men's hands, the fingers taper at the ends.

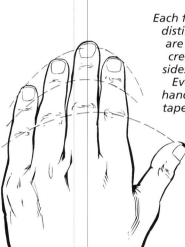

Look at the skeletal diagram of the hand above. Familiarize yourself with the arrangement of the bones and joints.

DRAWING HANDS AT VARIOUS ANGLES
Start with a big shape, then break it down into smaller shapes. Make sure to practice some *turnarounds,* an artist's term for rotating an object 360 degrees and drawing it from every angle (see pages 30–31).

Once you've gained some experience, you can draw "expressions" of the hand that are just as effective at conveying emotion as the face.

Note the various planes of the hand.

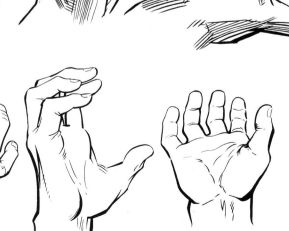

BASIC HAND POSES

L earn these basic hand poses and store them in your arsenal of techniques. Notice how all the joints of the fingers are apparent, even when they aren't bent.

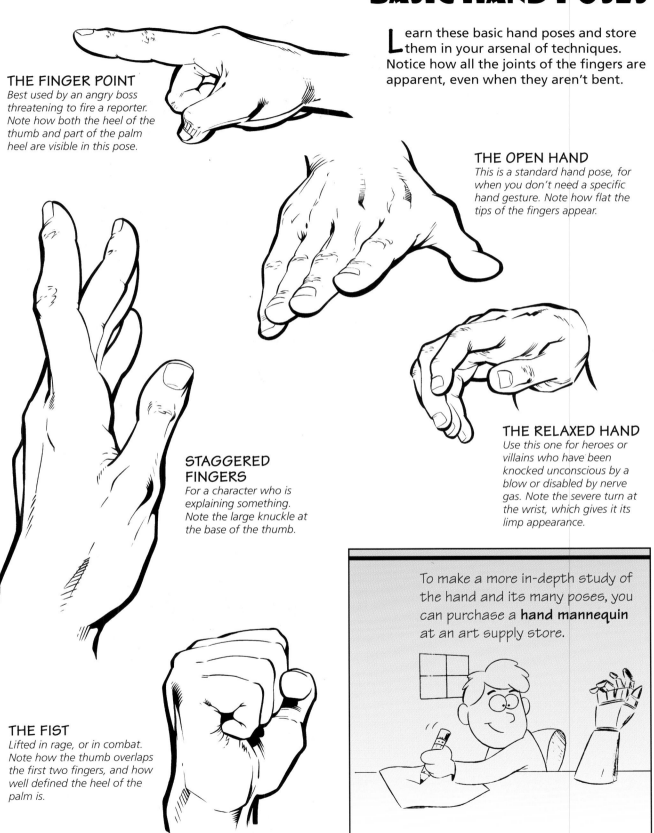

THE FINGER POINT
Best used by an angry boss threatening to fire a reporter. Note how both the heel of the thumb and part of the palm heel are visible in this pose.

THE OPEN HAND
This is a standard hand pose, for when you don't need a specific hand gesture. Note how flat the tips of the fingers appear.

STAGGERED FINGERS
For a character who is explaining something. Note the large knuckle at the base of the thumb.

THE RELAXED HAND
Use this one for heroes or villains who have been knocked unconscious by a blow or disabled by nerve gas. Note the severe turn at the wrist, which gives it its limp appearance.

THE FIST
Lifted in rage, or in combat. Note how the thumb overlaps the first two fingers, and how well defined the heel of the palm is.

To make a more in-depth study of the hand and its many poses, you can purchase a **hand mannequin** at an art supply store.

HEROIC HANDS

Artist Frank McLaughlin says, "The key to all comic book–style illustration is to exaggerate the form at the outset, then tone down whatever looks too extreme. *Don't* draw realistically and then try to soup it up. Your drawing will look overworked that way." Below are some helpful hints on drawing the heroic hand.

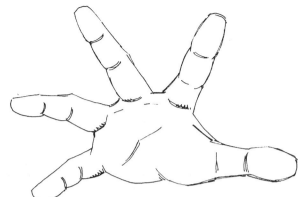

The webbing between fingers strains into straight lines as fingers are spread.

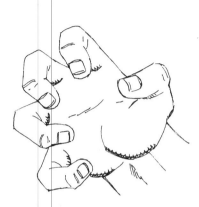

The tips of the fingers bend at a more extreme angle than on a normal hand.

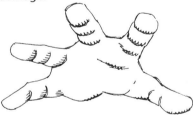

Massive knuckles on a fist can inflict maximum damage.

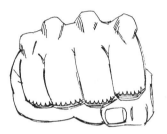

A powerful fist is always tilted downward, never up.

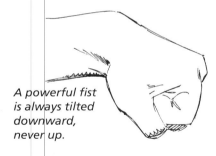

Shading the finger pads at the beginning of each joint gives this open hand a feeling of drama and dimension.

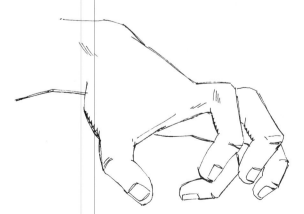

This dramatic hand gesture has many planes. The wrist is straight, then drops down on a diagonal to the fingers, which bend in three more angles.

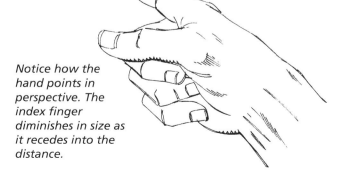

Notice how the hand points in perspective. The index finger diminishes in size as it recedes into the distance.

FEMALE HANDS

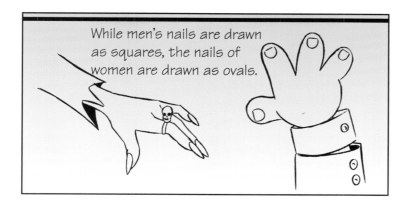

While men's nails are drawn as squares, the nails of women are drawn as ovals.

Female hands are more slender and graceful than their male counterpart's. Female hand poses tend to be less extreme, and the palm's thumb muscle is less pronounced.

Avoid heavy knuckle lines on a female hand, and leave off the rings and jewelry unless they're part of a secret weapon or power.

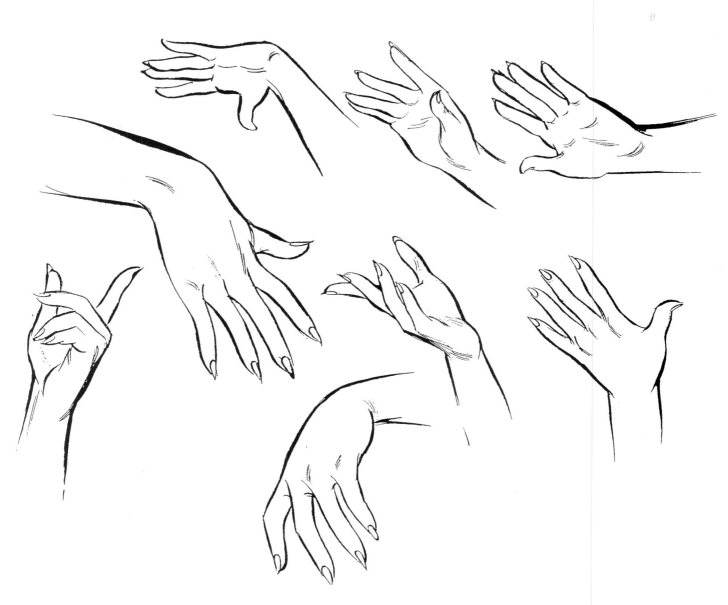

TURNAROUNDS

You must be able to draw your character from every angle. The cut of the costume is different in the front than it is in the back and on the sides. The posture is different, and the muscle groupings that the costume reveals are different, too. The look of the hair and the way that it hangs are also very different.

Before you actually begin to draw a story, make sure you've familiarized yourself with every angle of your character's appearance. That way, you won't feel the need to favor the easiest angle. In comic books, excitement is created by varying the angles of the figure on the page. If you can't draw those angles, the excitement will be irretrievably lost.

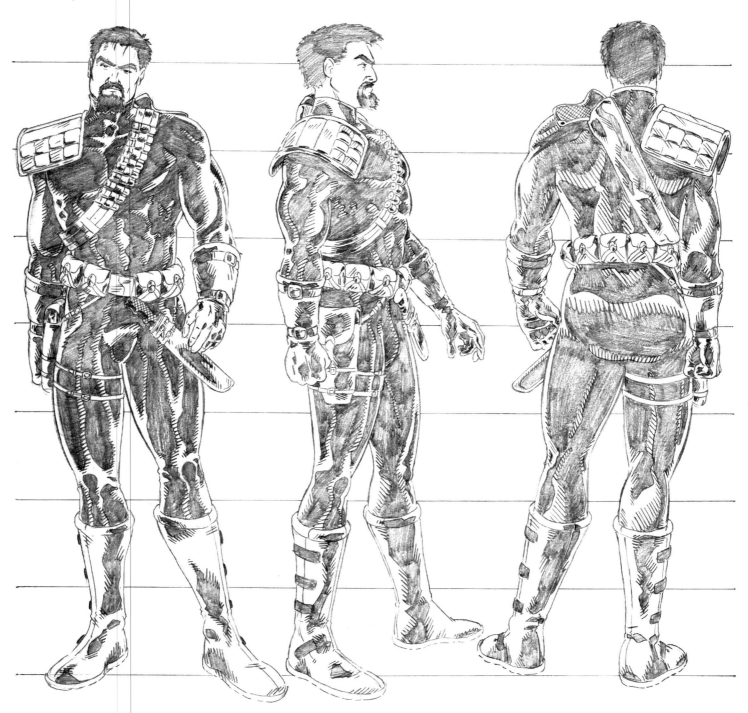

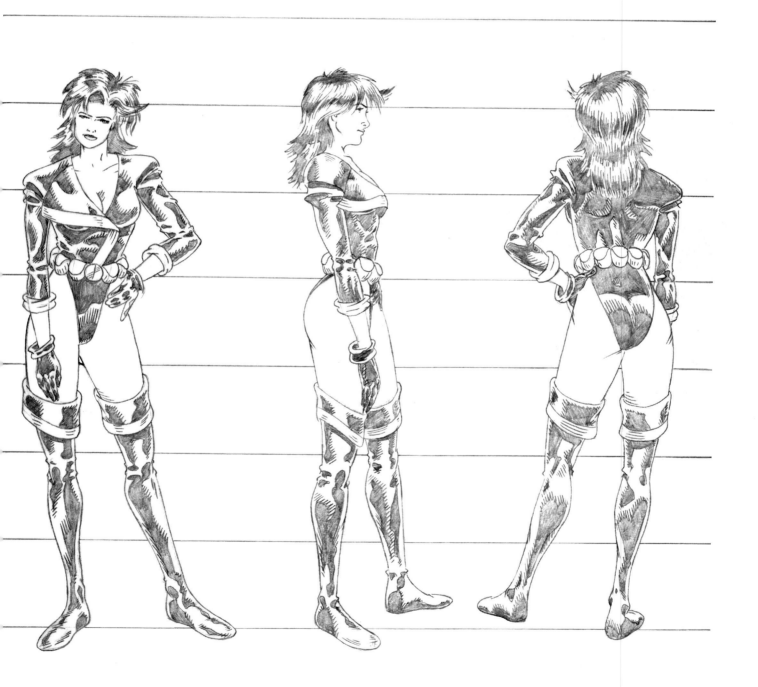

LET'S TAKE THE GLOVES OFF! Comic book fans will wade through any story if there's the promise of a really good fight scene at the end. These characters are built for one thing only—and I don't mean dancing! The key to drawing a great fight scene is understanding how the human figure adapts to motion and momentum. So take off your gloves and let's at 'em!

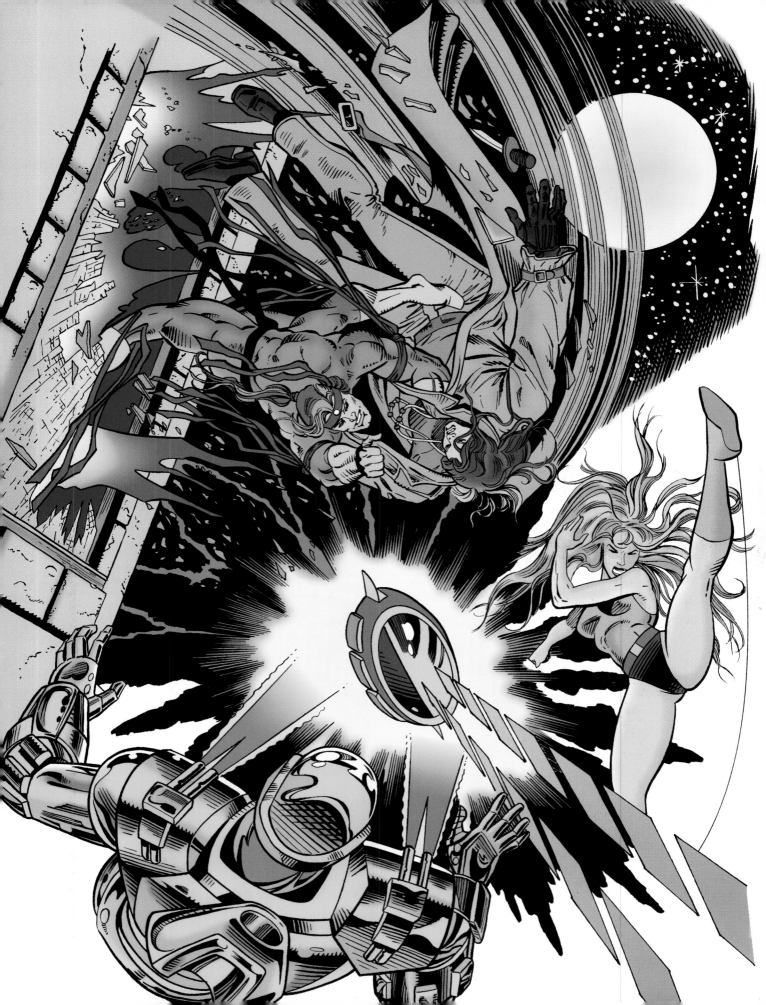

DEVASTATING PUNCHES

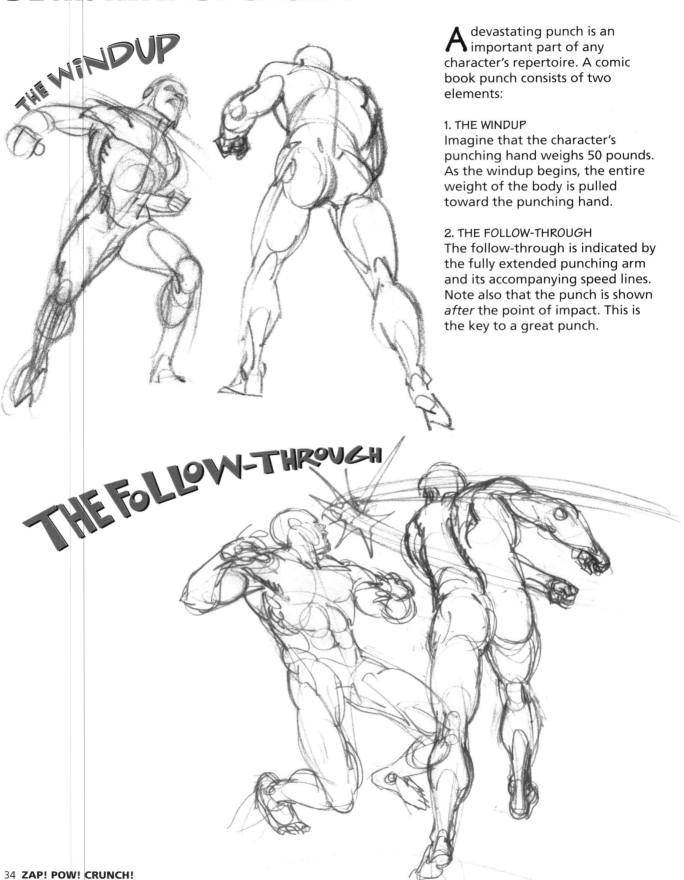

THE WINDUP

THE FOLLOW-THROUGH

A devastating punch is an important part of any character's repertoire. A comic book punch consists of two elements:

1. THE WINDUP
Imagine that the character's punching hand weighs 50 pounds. As the windup begins, the entire weight of the body is pulled toward the punching hand.

2. THE FOLLOW-THROUGH
The follow-through is indicated by the fully extended punching arm and its accompanying speed lines. Note also that the punch is shown *after* the point of impact. This is the key to a great punch.

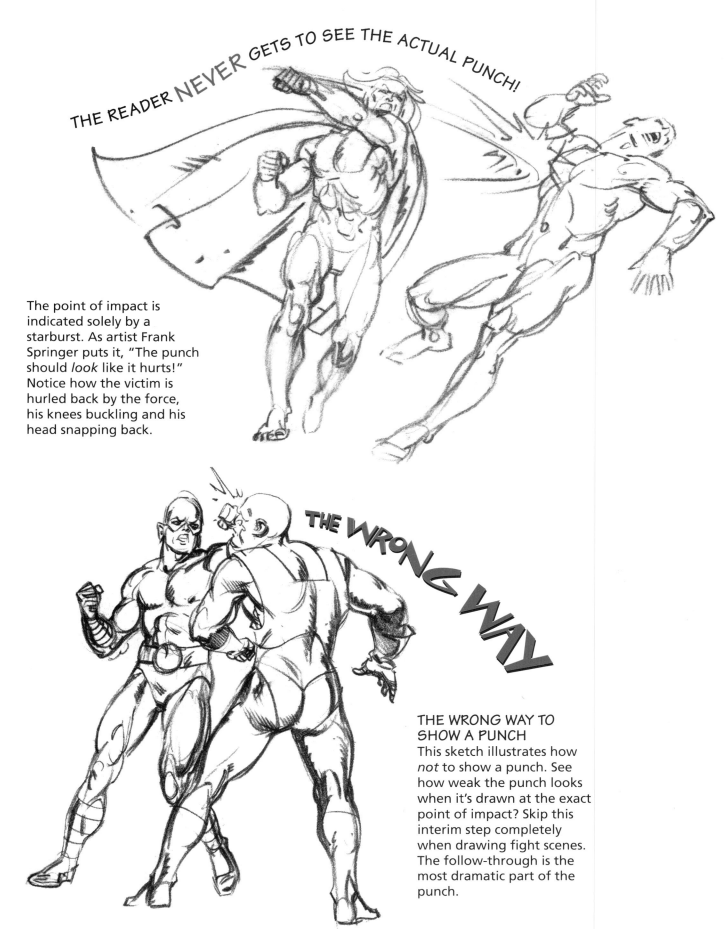

THE READER *NEVER* GETS TO SEE THE ACTUAL PUNCH!

The point of impact is indicated solely by a starburst. As artist Frank Springer puts it, "The punch should *look* like it hurts!" Notice how the victim is hurled back by the force, his knees buckling and his head snapping back.

THE WRONG WAY

THE WRONG WAY TO SHOW A PUNCH

This sketch illustrates how *not* to show a punch. See how weak the punch looks when it's drawn at the exact point of impact? Skip this interim step completely when drawing fight scenes. The follow-through is the most dramatic part of the punch.

CLEAN PUNCHES

There are no small punches in a comic book fight. Every punch is a haymaker. Because fight scenes frequently show overlapping figures (as in this series of sketches), be sure to space the characters so that the reader can easily see the completed punch at full extension. Short uppercuts and hooks aren't dramatic.

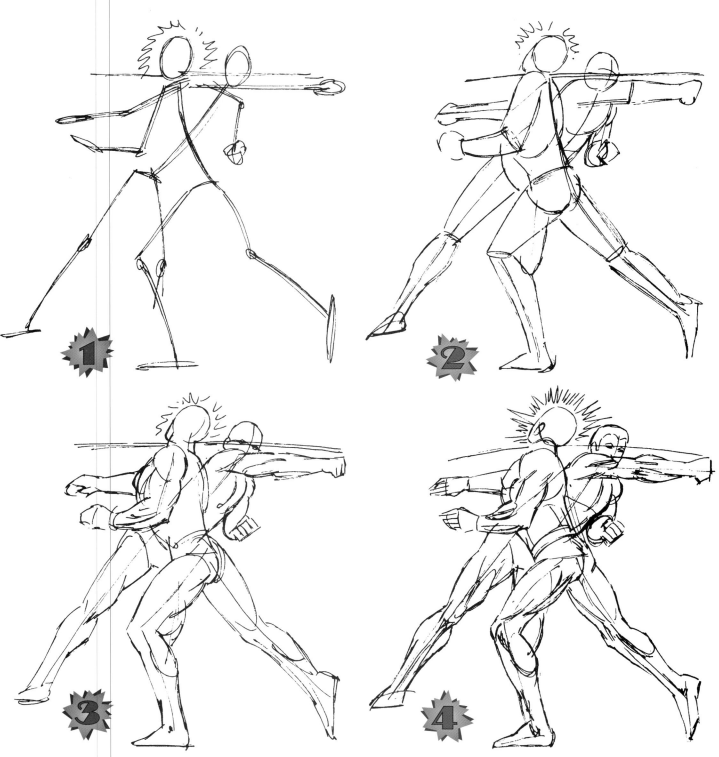

THE LUNGE ATTACK

We're all nice guys in this business, but sometimes we want our characters to go for the kill. Any lunge or attack movement needs to be swift, sudden, and totally forward-moving.

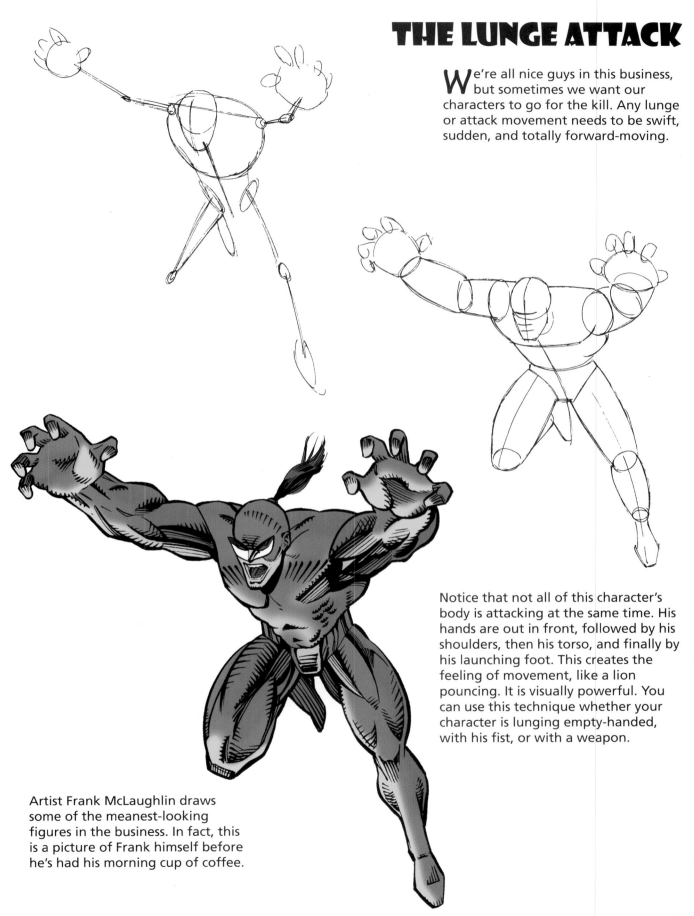

Notice that not all of this character's body is attacking at the same time. His hands are out in front, followed by his shoulders, then his torso, and finally by his launching foot. This creates the feeling of movement, like a lion pouncing. It is visually powerful. You can use this technique whether your character is lunging empty-handed, with his fist, or with a weapon.

Artist Frank McLaughlin draws some of the meanest-looking figures in the business. In fact, this is a picture of Frank himself before he's had his morning cup of coffee.

LEANING INTO THE PUNCH OR KICK

It may seem natural to lean back to throw a kick. But to do so means you're throwing your energy away from the target. Your character should lean *into* his punch or kick, thrusting all his weight forward. The character who lands the hard punch or kick has *both* his fists tightly clenched, while the character receiving the blow slackens his fists slightly, a sign of weakness.

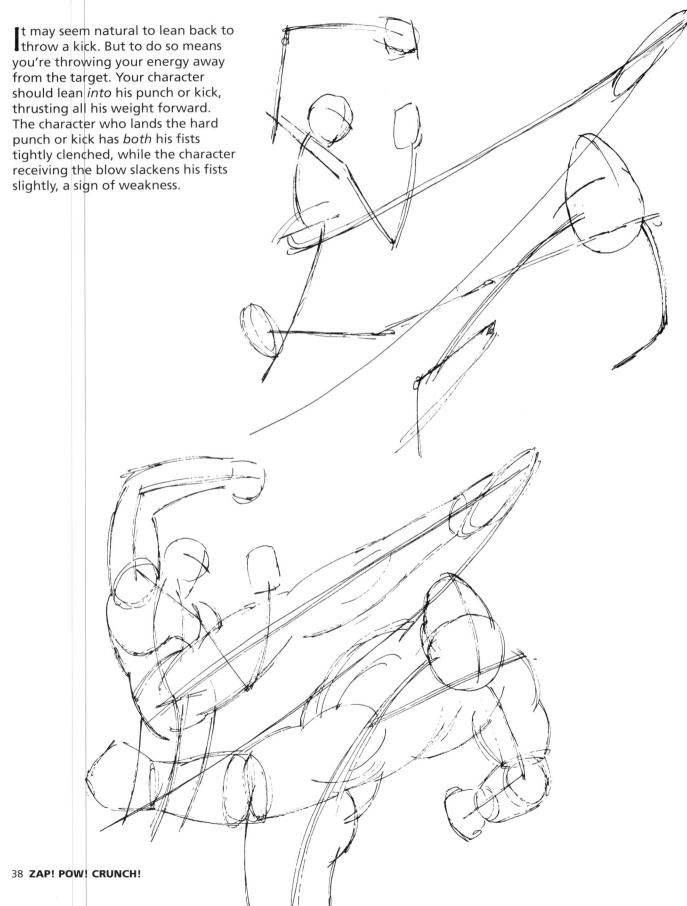

You can demonstrate the impact on the opponent most clearly by drawing his chin up in the air, as if he'd gotten socked right there. This is a clear sign that the punch was effective.

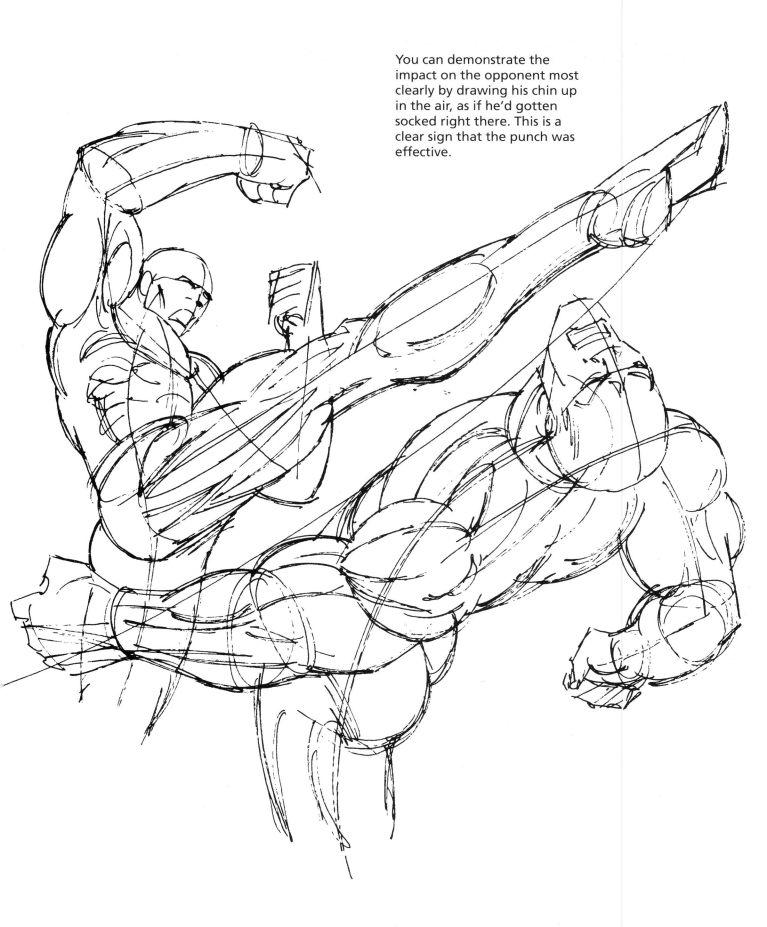

THE JUDO SHOULDER THROW

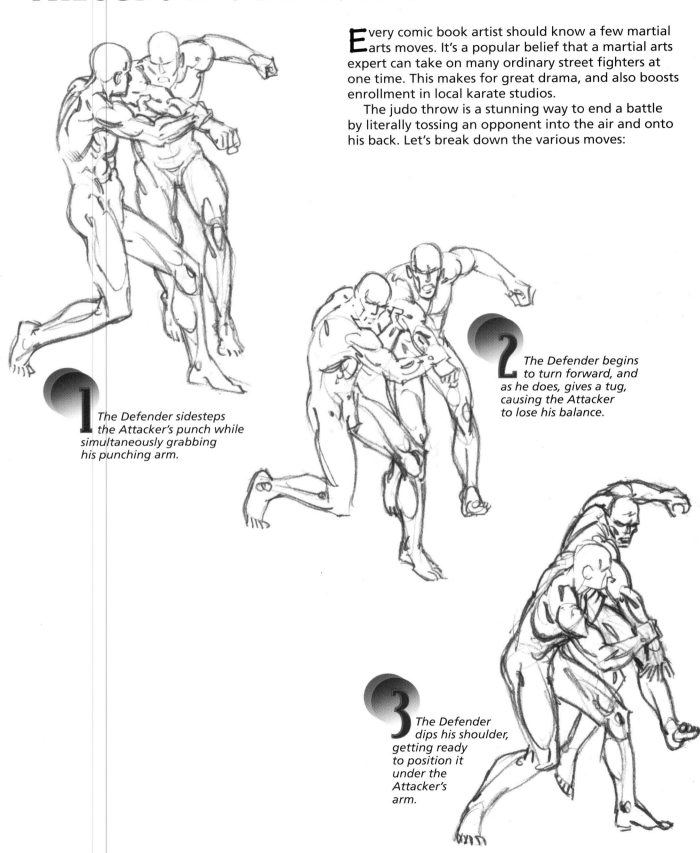

Every comic book artist should know a few martial arts moves. It's a popular belief that a martial arts expert can take on many ordinary street fighters at one time. This makes for great drama, and also boosts enrollment in local karate studios.

The judo throw is a stunning way to end a battle by literally tossing an opponent into the air and onto his back. Let's break down the various moves:

1 *The Defender sidesteps the Attacker's punch while simultaneously grabbing his punching arm.*

2 *The Defender begins to turn forward, and as he does, gives a tug, causing the Attacker to lose his balance.*

3 *The Defender dips his shoulder, getting ready to position it under the Attacker's arm.*

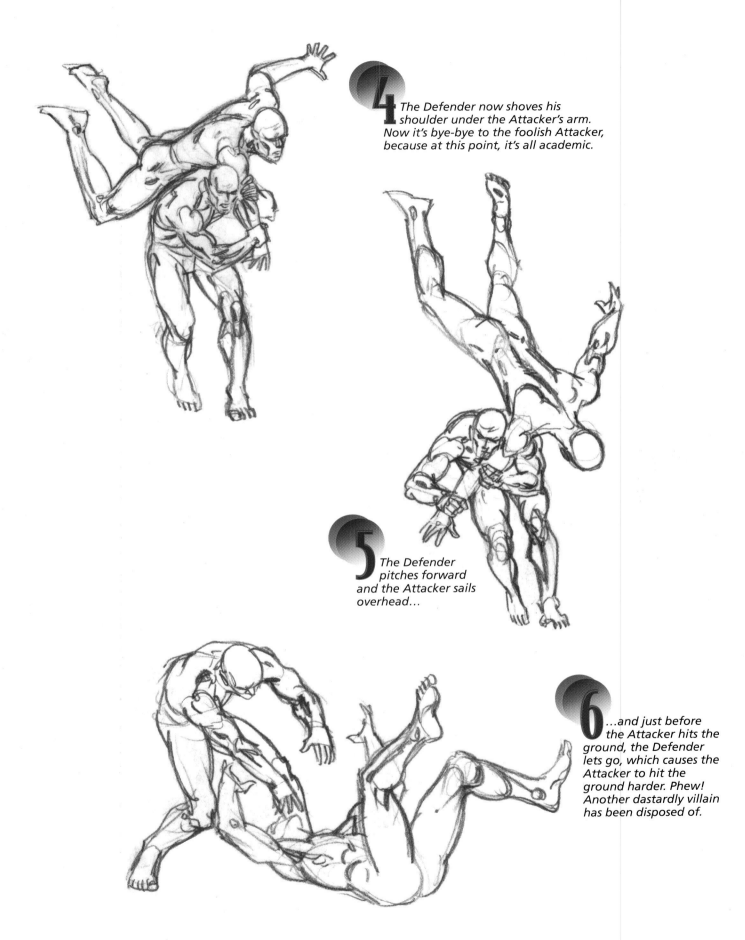

4 *The Defender now shoves his shoulder under the Attacker's arm. Now it's bye-bye to the foolish Attacker, because at this point, it's all academic.*

5 *The Defender pitches forward and the Attacker sails overhead…*

6 *…and just before the Attacker hits the ground, the Defender lets go, which causes the Attacker to hit the ground harder. Phew! Another dastardly villain has been disposed of.*

DAVID VS. GOLIATH

An unfair fight is a very dramatic device, and has been since time immemorial. Casting the hero as the underdog, who must win against insurmountable odds, makes us want to root for him, and if he starts the scene by ostensibly fighting a losing battle, only to come from behind to win through sheer heart, the fight will be truly exciting.

Make sure the giant nemesis uses his physical advantages of strength and size in the fight scene.

When a towering brute fights a smaller man, the latter is usually the hero.

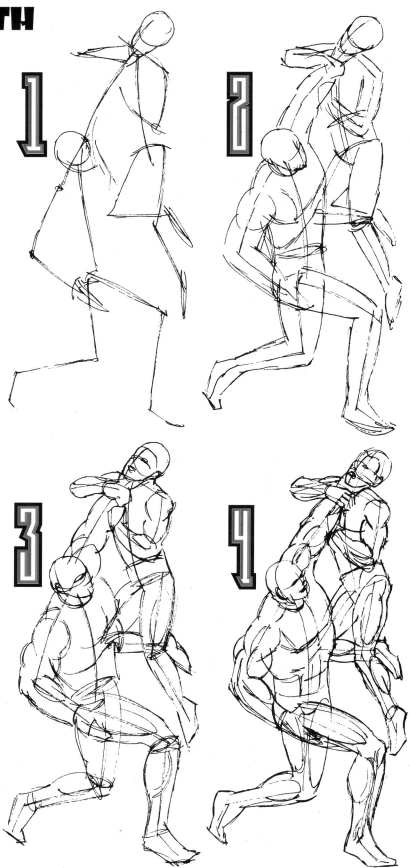

THE BALANCE OF POWER

You don't always have to throw a punch to win a fight—provided you're a comic book character. Super powers, such as body force fields, can repel an attack, hurling someone even farther than the most powerful punch.

The most important thing to remember when designing super powers for your characters is this: A character should also have a weakness. Why is that so important? Think about it. If your character is so strong that he or she can't possibly be beaten, then why watch the fight? Even Superman needed Kryptonite to heighten the suspense. The weakness doesn't have to be physical—your character could have a thing for a "bad girl." Design a weakness that's as original as the special powers you've invented.

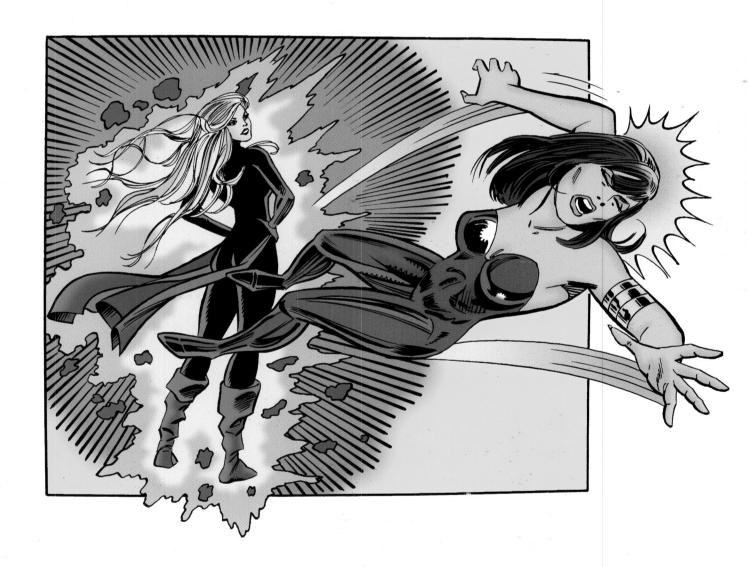

FANTASTIC FOES

VILLAINS TODAY ARE NOT JUST BAD GUYS. They're vile, repulsive, wicked, sadistic, insane, evil, bad guys. They're worse than the guy who's dating your sister. Here's an important secret about comic book villains: The more powerful and formidable the villain, the greater the hero. Villains have a wonderful time being wicked. So have fun creating an impressive villain. After all, it's an evil job, but someone's got to do it!

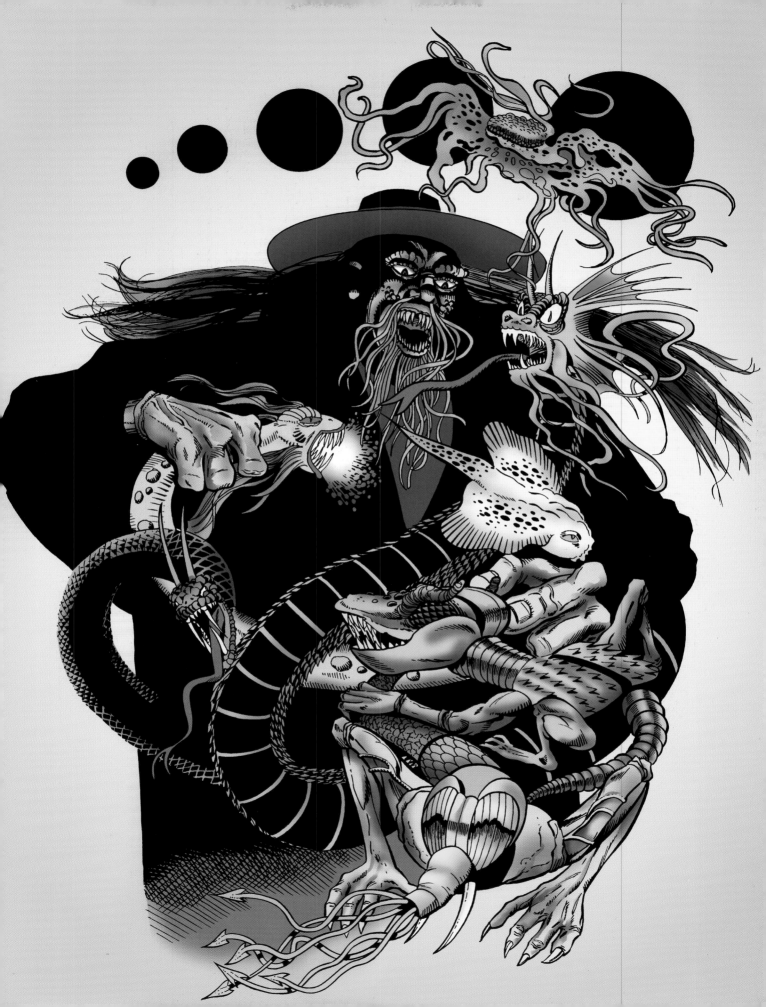

THE RENEGADE SOLDIER

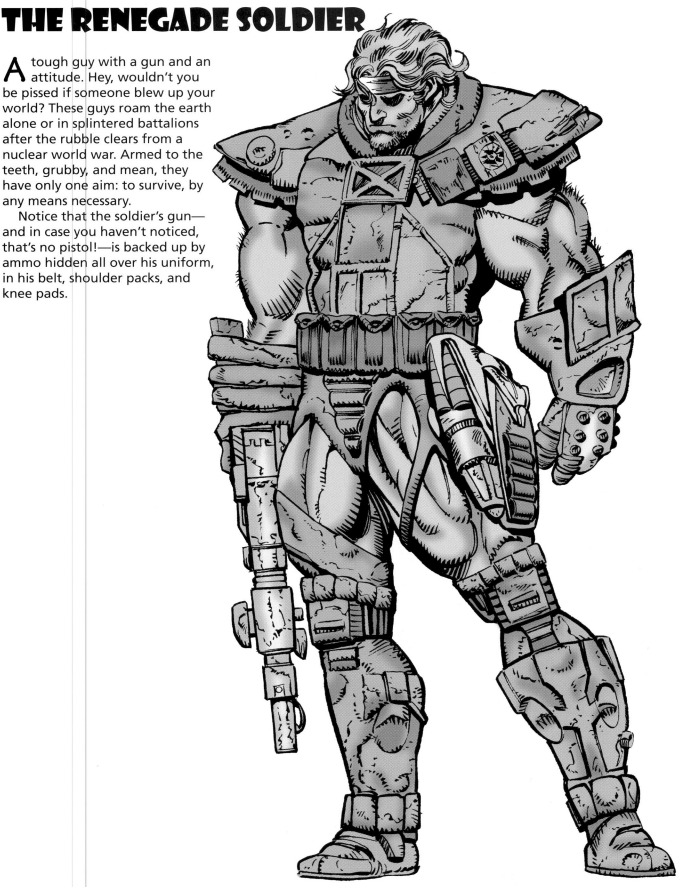

A tough guy with a gun and an attitude. Hey, wouldn't you be pissed if someone blew up your world? These guys roam the earth alone or in splintered battalions after the rubble clears from a nuclear world war. Armed to the teeth, grubby, and mean, they have only one aim: to survive, by any means necessary.

Notice that the soldier's gun—and in case you haven't noticed, that's no pistol!—is backed up by ammo hidden all over his uniform, in his belt, shoulder packs, and knee pads.

SWORD-AND-SORCERY VILLAINS

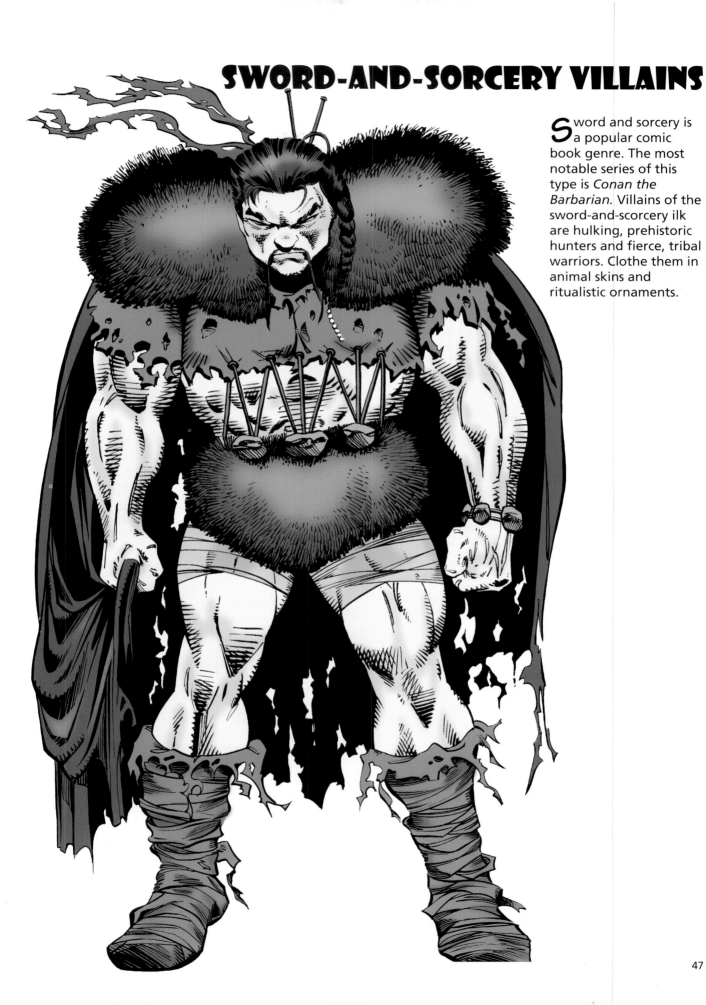

Sword and sorcery is a popular comic book genre. The most notable series of this type is *Conan the Barbarian.* Villains of the sword-and-scorcery ilk are hulking, prehistoric hunters and fierce, tribal warriors. Clothe them in animal skins and ritualistic ornaments.

FORCES OF EVIL

If you ask any Hollywood star what role he or she enjoyed playing the most, the answer will inevitably be, "The bad guy." Bad guys are just more fun because they're so wicked and single-minded. They don't have to worry about being nice. Or playing fair. However, they can be quite charming, elegant, polite—even fastidious. And deadly.

Why are we so fascinated with bad guys? Maybe because bad guys come from primitive, subconscious images of evil. The things that go bump in the night—rats, bats, snakes, lizards, wolves, and spiders. If it can make your skin crawl, it can make a great bad guy.

Don't be literal in transforming creepy crawlies into villains. The days of giant ants that devour a city are over. Use nightmarish images to suggest a villainous personality. A spidery black cape on a vampire-like woman is much better than giving her eight spider arms. Don't repulse your audience; lure them in.

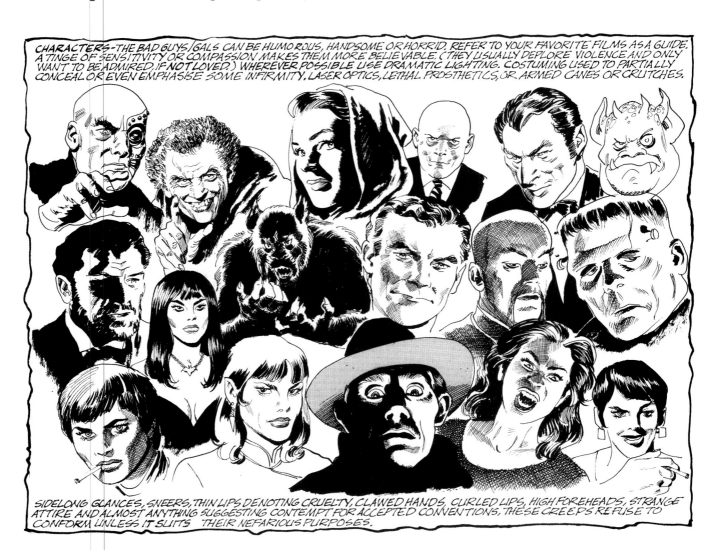

CHARACTERS—THE BAD GUYS/GALS CAN BE HUMOROUS, HANDSOME OR HORRID, REFER TO YOUR FAVORITE FILMS AS A GUIDE. A TINGE OF SENSITIVITY OR COMPASSION MAKES THEM MORE BELIEVABLE. (THEY USUALLY DEPLORE VIOLENCE AND ONLY WANT TO BE ADMIRED, IF NOT LOVED.) WHEREVER POSSIBLE USE DRAMATIC LIGHTING. COSTUMING USED TO PARTIALLY CONCEAL OR EVEN EMPHASIZE SOME INFIRMITY, LASER OPTICS, LETHAL PROSTHETICS, OR ARMED CANES OR CRUTCHES.

SIDELONG GLANCES, SNEERS, THIN LIPS DENOTING CRUELTY. CLAWED HANDS, CURLED LIPS, HIGH FOREHEADS, STRANGE ATTIRE AND ALMOST ANYTHING SUGGESTING CONTEMPT FOR ACCEPTED CONVENTIONS, THESE CREEPS REFUSE TO CONFORM UNLESS IT SUITS THEIR NEFARIOUS PURPOSES.

INVENTING A VILLAIN

*C*hances are, your villain started out as an average guy, just like you or me, but somewhere along the line he got dipped into a vat of toxic waste, was exposed to a strange radioactive brew, or became the victim of an industrial accident. He became embittered. Vengeful. Delusional. Insane. As a result, his appearance changed. He may have had to replace parts of his face, or they may have even mutated. So you can start by drawing an ordinary face, and by playing around with it, changing it little by little, you can transform it into the face of a consummate villain.

Sometimes it's enough that the evil inside a person shows itself on his or her face. Villains don't always have to be fiery. Sometimes the dispassion they exhibit is evil, too. This is the case with a bad-guy scientist who cruelly and relentlessly stalks new subjects for his experiments.

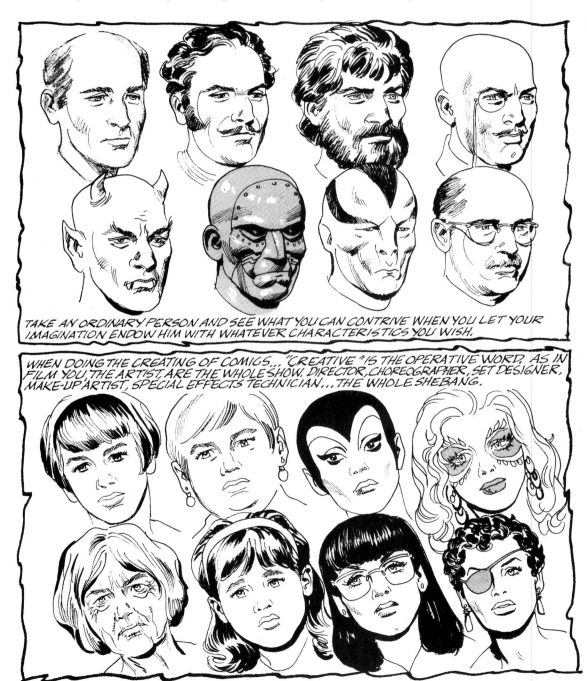

TAKE AN ORDINARY PERSON AND SEE WHAT YOU CAN CONTRIVE WHEN YOU LET YOUR IMAGINATION ENDOW HIM WITH WHATEVER CHARACTERISTICS YOU WISH.

WHEN DOING THE CREATING OF COMICS..."CREATIVE" IS THE OPERATIVE WORD. AS IN FILM YOU, THE ARTIST, ARE THE WHOLE SHOW. DIRECTOR, CHOREOGRAPHER, SET DESIGNER, MAKE-UP ARTIST, SPECIAL EFFECTS TECHNICIAN...THE WHOLE SHEBANG.

BEASTLY VILLAINS

Half man and half beast. These villains are totally unpredictable, just like wild animals. You can combine the human form with any animal's to create a convincing foe. This type of villain gives the impression of being physically stronger than its purely human counterpart. It is especially effective if the animal you choose is a predator.

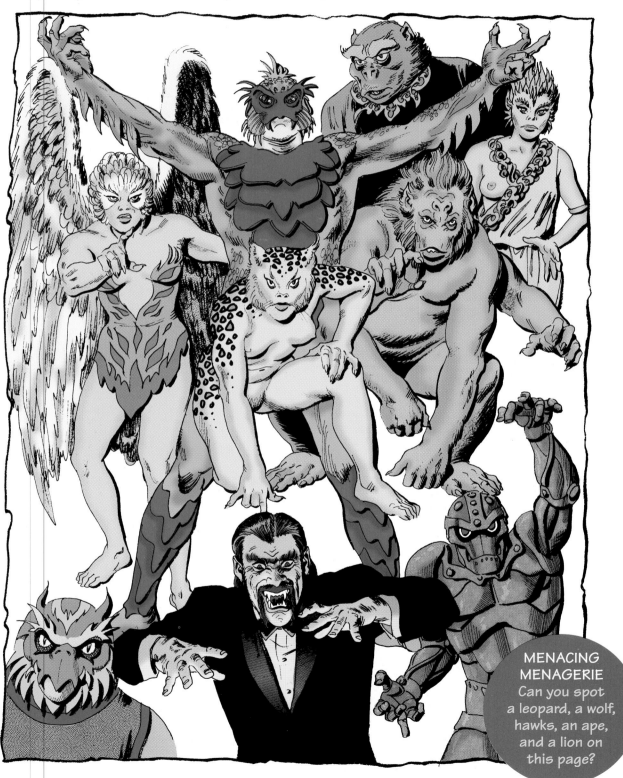

MENACING MENAGERIE
Can you spot a leopard, a wolf, hawks, an ape, and a lion on this page?

HOLLYWOOD HEAVIES

When inspiration vanishes, as it sometimes does, there are ways of getting around it. Pick a silver-screen bad guy—either famous or not-so-famous—and draw a loose likeness. Then start altering his features. You can change them any way you like—make him taller or shorter, fatter or thinner, older or younger—but be sure to maintain that twinkle of villainy in his eye. You won't have to change very much before you've added a new character to your cast.

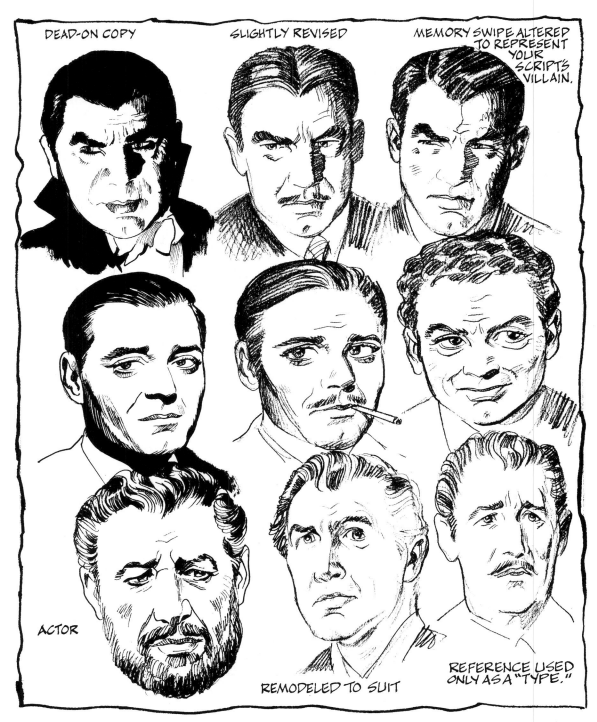

DEAD-ON COPY

SLIGHTLY REVISED

MEMORY SWIPE ALTERED TO REPRESENT YOUR SCRIPT'S VILLAIN.

ACTOR

REMODELED TO SUIT

REFERENCE USED ONLY AS A "TYPE."

DRESSED TO KILL

The bad guys *enjoy* their costumes. They love their jobs and they like their uniforms. They are egomaniacs with inferiority complexes. Good guys wear their costumes out of a sense of duty, even though they're frequently no more practical than the bad guys'. When designing a costume for a bad guy, make sure it reflects his or her personality. Is it ostentatious? Dark or sexy? You decide.

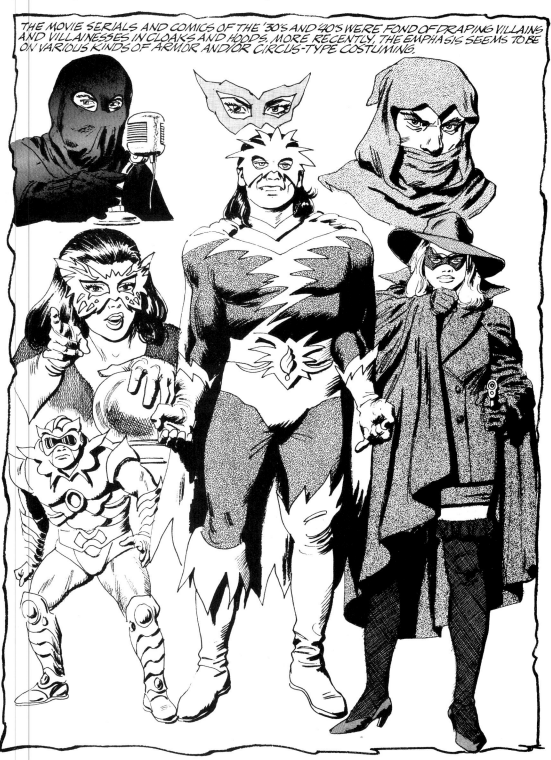

THE MOVIE SERIALS AND COMICS OF THE '30's AND '40's WERE FOND OF DRAPING VILLAINS AND VILLAINESSES IN CLOAKS AND HOODS. MORE RECENTLY, THE EMPHASIS SEEMS TO BE ON VARIOUS KINDS OF ARMOR AND/OR CIRCUS-TYPE COSTUMING.

UNEARTHLY CREATURES

Evil creatures are a recurring—and frequent—comic book device. You can find inspiration in the monstrous images of myths and fables, like the Medusa or Cyclops, or you can use your own imagination and any assortment of shapes in your drawings.

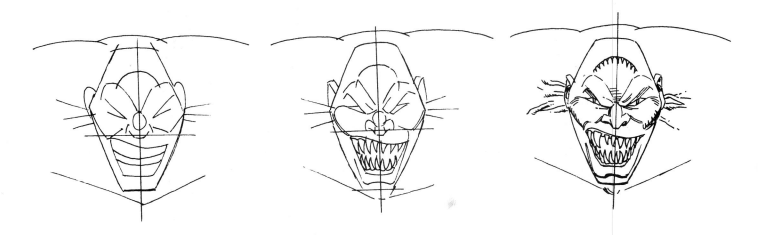

A word of caution: If you create an ornate, incredibly complex creature with lots of bumps and teeth, just remember that you're going to have to draw it over and over again in every panel. Design something you can live with.

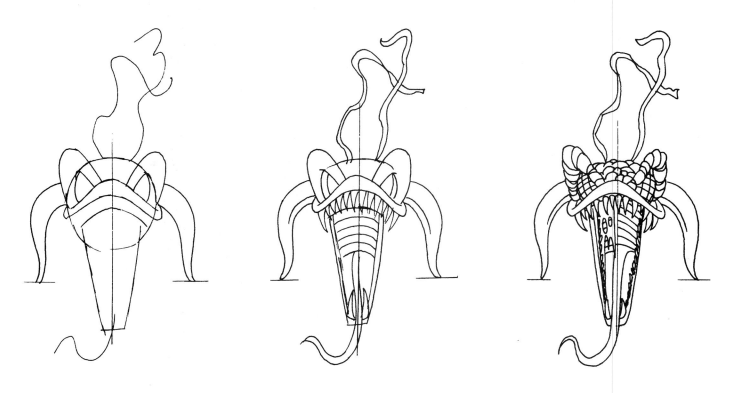

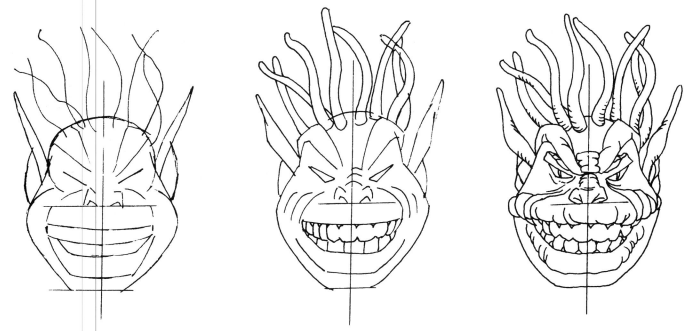

Not even a mother could love these faces. Worms sprouting out of heads isn't something you see every day. Shrunken heads may also be a little excessive. But your job as a comic book artist is to elicit a response from the seasoned comic book reader, who has seen just about everything. So take it to the limit—be extreme.

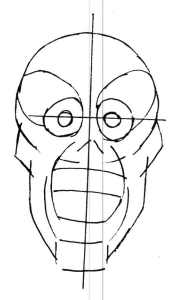 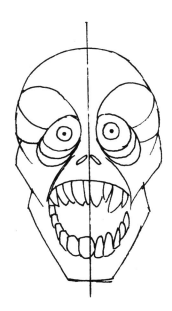

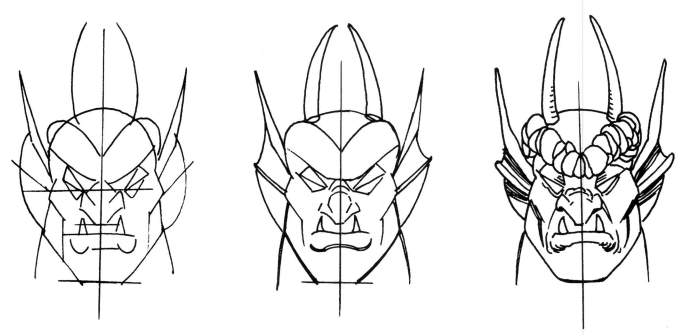

Horns, pointed ears, sharp teeth, scales, warts, and fur are all popular. As long as it doesn't make the drawing look cluttered, you can pile on as many of these kinds of features as you want. Design your creature's face to appear frightening at all times, regardless of expression.

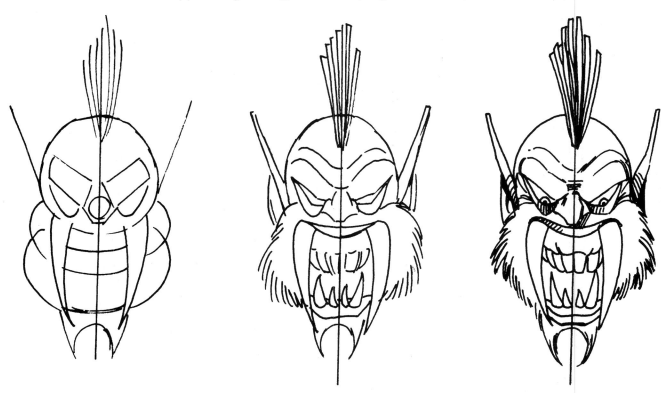

BEAUTIFUL But DEADLY

WHAT WOULD A BOOK ABOUT COMIC BOOKS be without a chapter devoted to the gorgeous women who grace their pages? As any fan will tell you, these fabulous females are a large part of the allure of comic books. Just as male comic book heroes are depicted with an exaggerated masculinity, comic book females are drawn in a way that capitalizes on their sex appeal as well as their strength and resourcefulness.

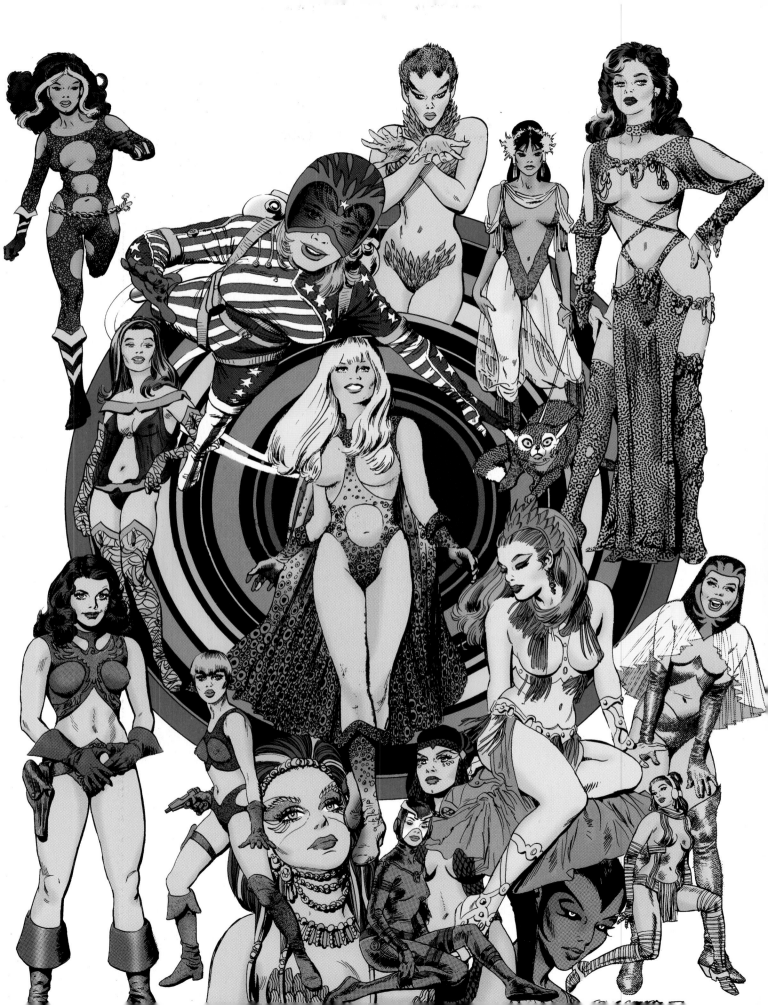

COMIC BOOK BEAUTIES THEN...

Artist Gray Morrow, who is renowned for his illustrations of beautiful women, shares his point of view on the origins of and latest developments in designing and drawing female comic book characters. "In comics as well as in film and other forms of fiction, the femme fatales generally fall into a few stereotypical categories. The provocative good/bad or all-out bad girl in comic books has been with us for quite a while.

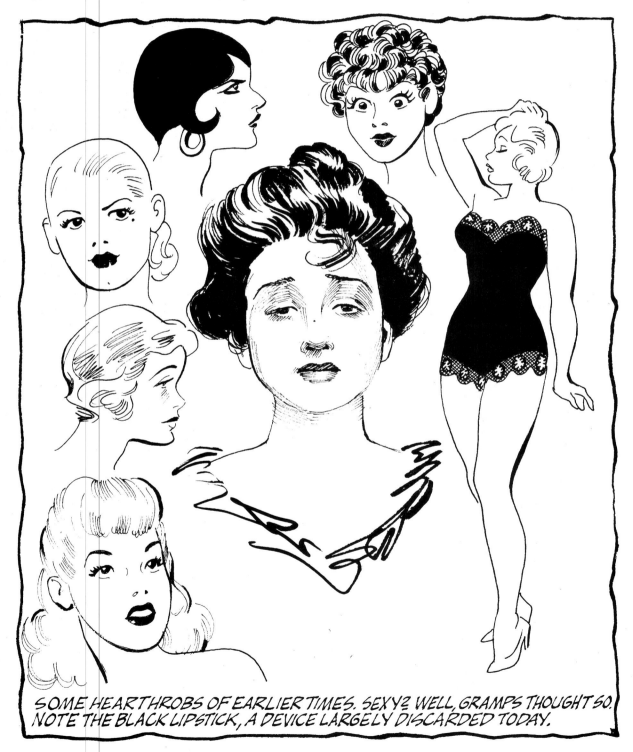

SOME HEARTHROBS OF EARLIER TIMES. SEXY? WELL, GRAMPS THOUGHT SO. NOTE THE BLACK LIPSTICK, A DEVICE LARGELY DISCARDED TODAY.

"Certainly not the first, but perhaps one of the earliest to make an indelible impression, was Milton Caniff's 'Dragon Lady.' She remains to this day a model for that eternally mysterious and fascinating example of an independent, self-reliant, and sometimes amoral, if not immoral, female, scornful of all males, except, of course, the 'Good Guy' hero. She and her clones, while somewhat varied, had many similarities."

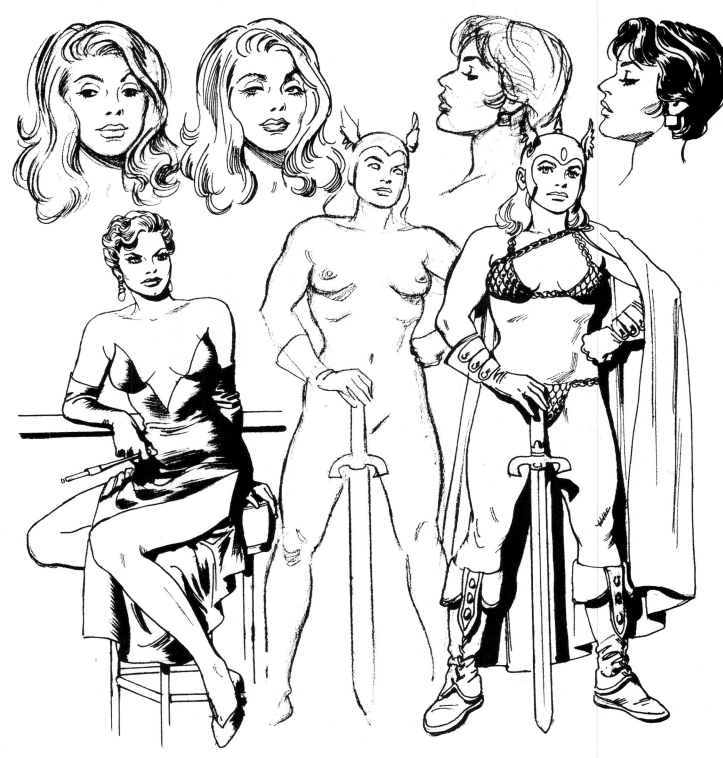

FEMME FATALES YESTERDAY...

"Theda Bara, 'the Vamp' of silent films, raised our grandfathers' blood pressures several notches and inspired a number of look-alikes, though she was somewhat toned down in the realm of printed matter. The 'Dragon Lady' type has, in our modern lexicon, become synonymous with the 'vamp.' So how do we recreate her?

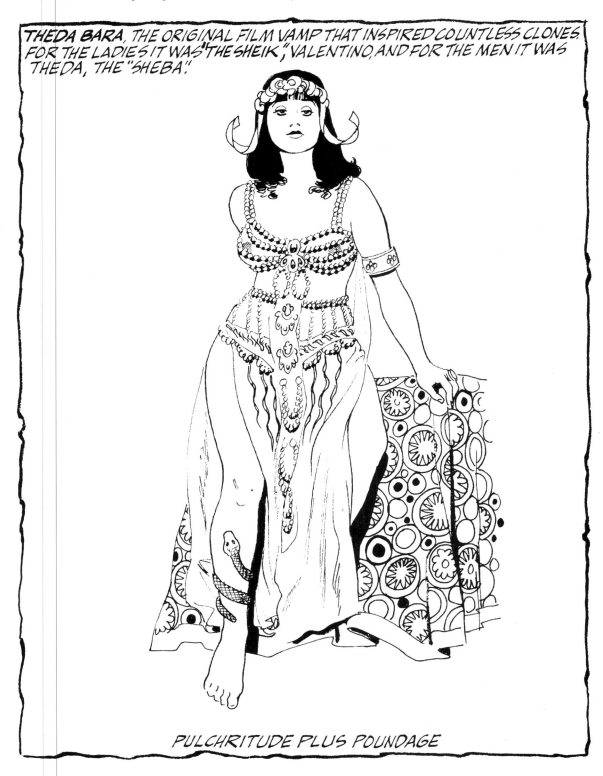

THEDA BARA, THE ORIGINAL FILM VAMP THAT INSPIRED COUNTLESS CLONES, FOR THE LADIES IT WAS "THE SHEIK", VALENTINO, AND FOR THE MEN IT WAS THEDA, THE "SHEBA".

PULCHRITUDE PLUS POUNDAGE

...AND TODAY

"The femme fatale must have an exquisite form. In today's more permissive media, we can get nearly as explicit as anyone would want. She should be slinky, catlike in her movements, arched eyebrows, slitted eyes, always posturing, and—even today—smoking! She doesn't give a damn about the 'big C' or the environment. She can be big-breasted or streamlined, or even very muscular—and therefore doubly dangerous. She just might possibly be a match for the hapless hero. Her costuming should be exotic, alluring, daring, and even alien or offbeat."

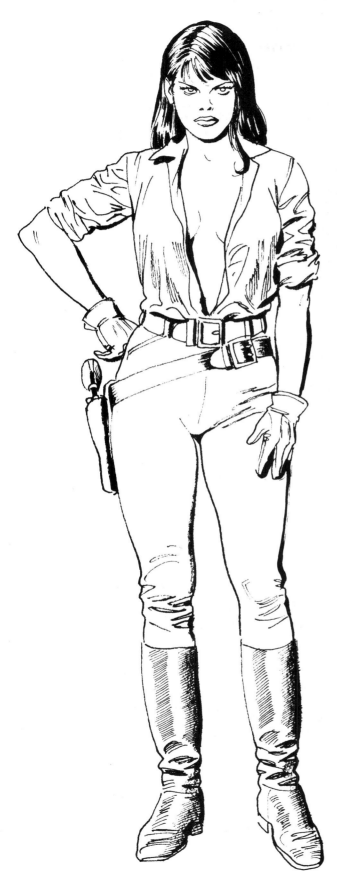

EVEN WITH "SUPERWOMEN" EXCESSIVE MUSCULAR DEFINITION IS NOT DESIREABLE. SUCH DELINIATION GIVES A FLAYED OR "RIPPED" LOOK DISTINCTLY UNFEMININE. TRY TO "FEEL" THE FORM AND STRIVE FOR PROPORTIONS THAT SUGGEST POWER WITHOUT HAVING A FIGURE THAT LOOKS LIKE AN ANATOMICAL DIAGRAM.

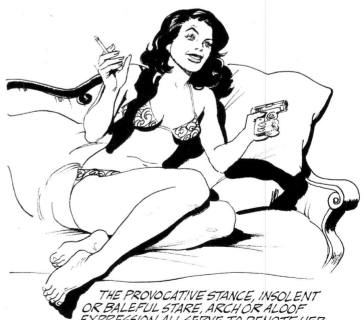

THE PROVOCATIVE STANCE, INSOLENT OR BALEFUL STARE, ARCH OR ALOOF EXPRESSION ALL SERVE TO DENOTE HER ANTISOCIAL, (A GUN HELPS), PERSONALITY. STUDY YOUR FAVORITE SULTRY SCREEN SIRENS TO LEARN MORE FROM THEIR "BAG OF TRICKS."

DENIZEN OF THE STREET

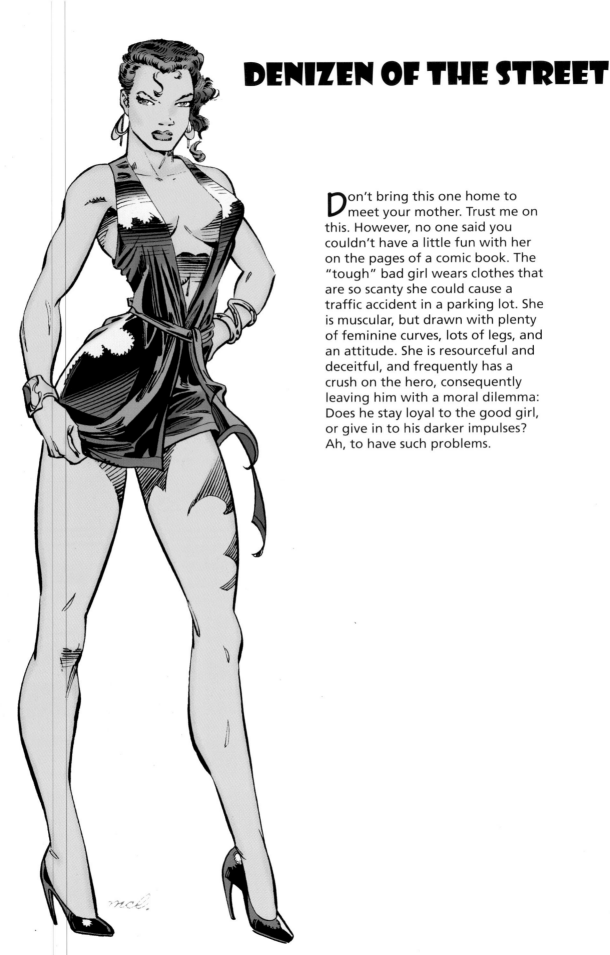

Don't bring this one home to meet your mother. Trust me on this. However, no one said you couldn't have a little fun with her on the pages of a comic book. The "tough" bad girl wears clothes that are so scanty she could cause a traffic accident in a parking lot. She is muscular, but drawn with plenty of feminine curves, lots of legs, and an attitude. She is resourceful and deceitful, and frequently has a crush on the hero, consequently leaving him with a moral dilemma: Does he stay loyal to the good girl, or give in to his darker impulses? Ah, to have such problems.

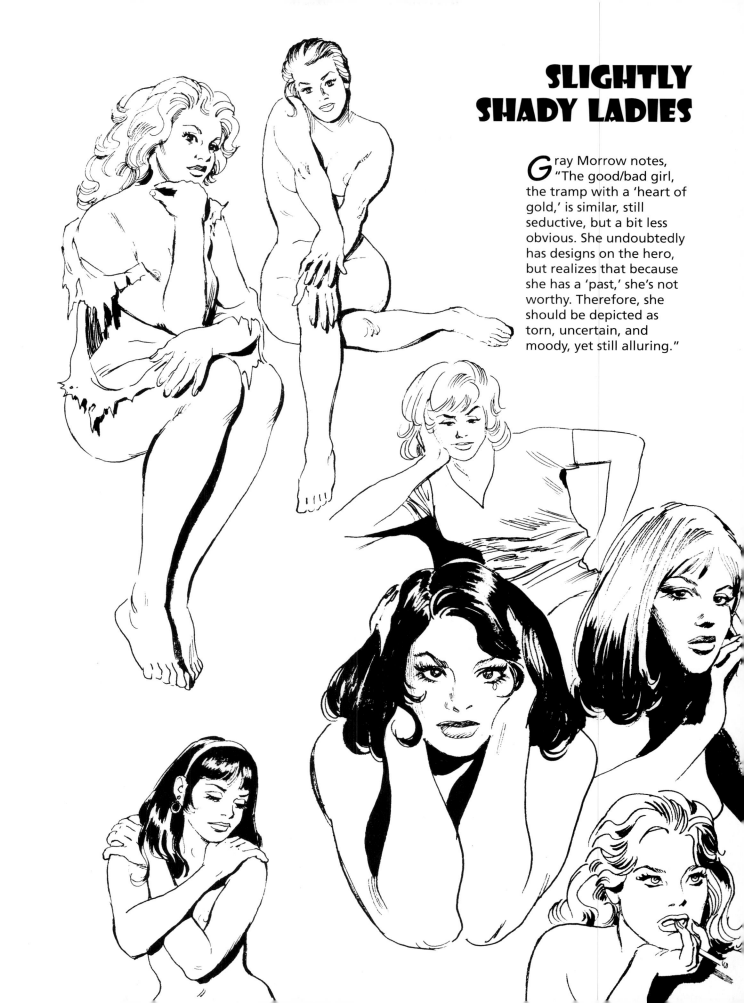

SLIGHTLY SHADY LADIES

Gray Morrow notes, "The good/bad girl, the tramp with a 'heart of gold,' is similar, still seductive, but a bit less obvious. She undoubtedly has designs on the hero, but realizes that because she has a 'past,' she's not worthy. Therefore, she should be depicted as torn, uncertain, and moody, yet still alluring."

THE CLASSIC "GOOD GIRL"

According to Morrow, "The 'Good Girl' is the gal next door: fresh, open, a pal. She's definitely sexy, but less obvious, and less affected, than her 'bad girl' sisters. She's exuberant, perky, sympathetic, pensive, and unsophisticated. The examples below are, of course, all stereotypes, presented as takeoff points or guidelines from which you can extrapolate your own."

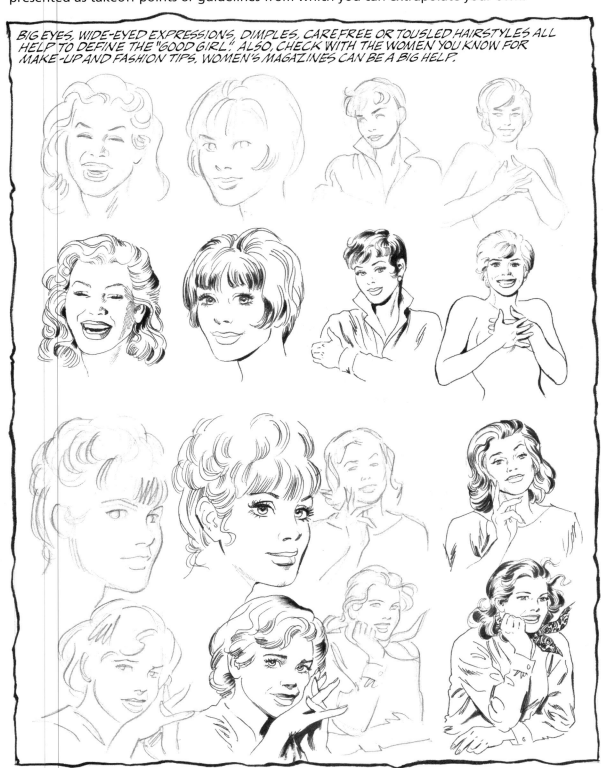

BIG EYES, WIDE-EYED EXPRESSIONS, DIMPLES, CAREFREE OR TOUSLED HAIRSTYLES ALL HELP TO DEFINE THE "GOOD GIRL". ALSO, CHECK WITH THE WOMEN YOU KNOW FOR MAKE-UP AND FASHION TIPS, WOMEN'S MAGAZINES CAN BE A BIG HELP.

BEAUTY IN ALL SHAPES AND COLORS

Morrow observes, "For some strange reason—perhaps because it's a hard skill to master—many, if not most, cartoonists, when drawing their version of a pretty girl, draw virtually the same girl all the time. Clothing and hair styles are changed to make one distinguishable from another, but features and figures remain the same. Since in real life there is an astonishing variety of attractive females, it seems a shame not to indicate that on paper."

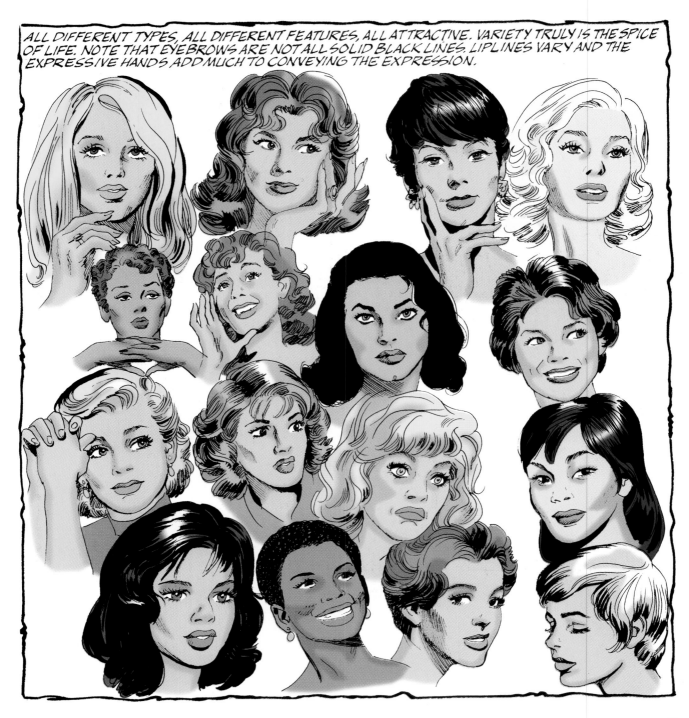

ALL DIFFERENT TYPES, ALL DIFFERENT FEATURES, ALL ATTRACTIVE. VARIETY TRULY IS THE SPICE OF LIFE. NOTE THAT EYEBROWS ARE NOT ALL SOLID BLACK LINES. LIPLINES VARY AND THE EXPRESSIVE HANDS ADD MUCH TO CONVEYING THE EXPRESSION.

"A good-looking girl can be short or tall, slender or voluptuous, with a wide array of facial characteristics—a beauty mark, full or thin lips, a cleft chin, an aquiline nose, high cheekbones, full lower lashes, and so on. Look around you and take note of the fact that not all 'gorgeous babes' are cookie-cutter Barbie Doll clones."

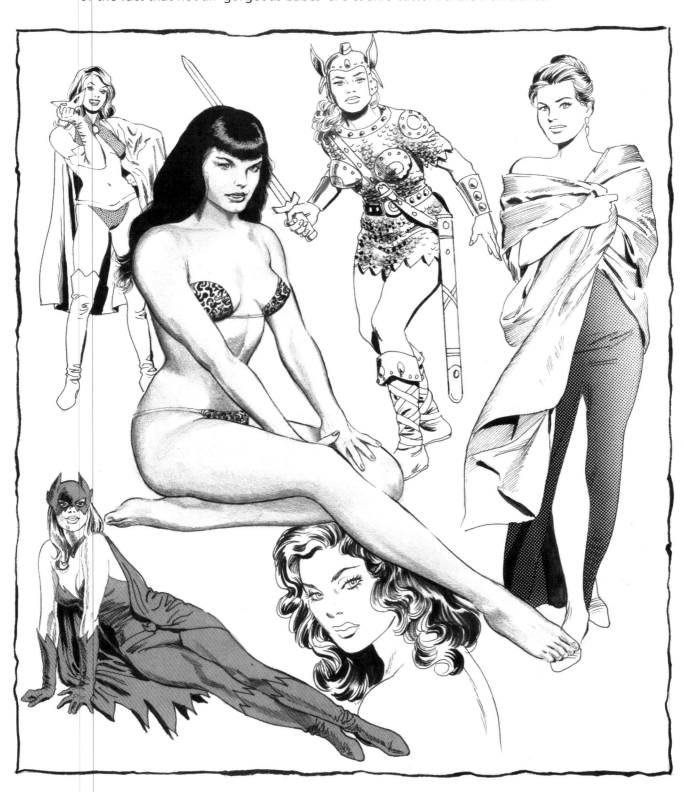

MOTHER NATURE IS BOUNTIFUL IN HER PROVISION OF MODEL TYPES. SEEK TO MAKE THEM CONVINC-ING BY GIVING THEM DISTINCTIVE CHARACTERISTICS, GESTURES, EXPRESSIONS, ATTITUDES. COSTUMING IS RARELY "SENSIBLE," BUT NOT TO WORRY - THESE GALS NEVER SEEM TO CATCH COLD.

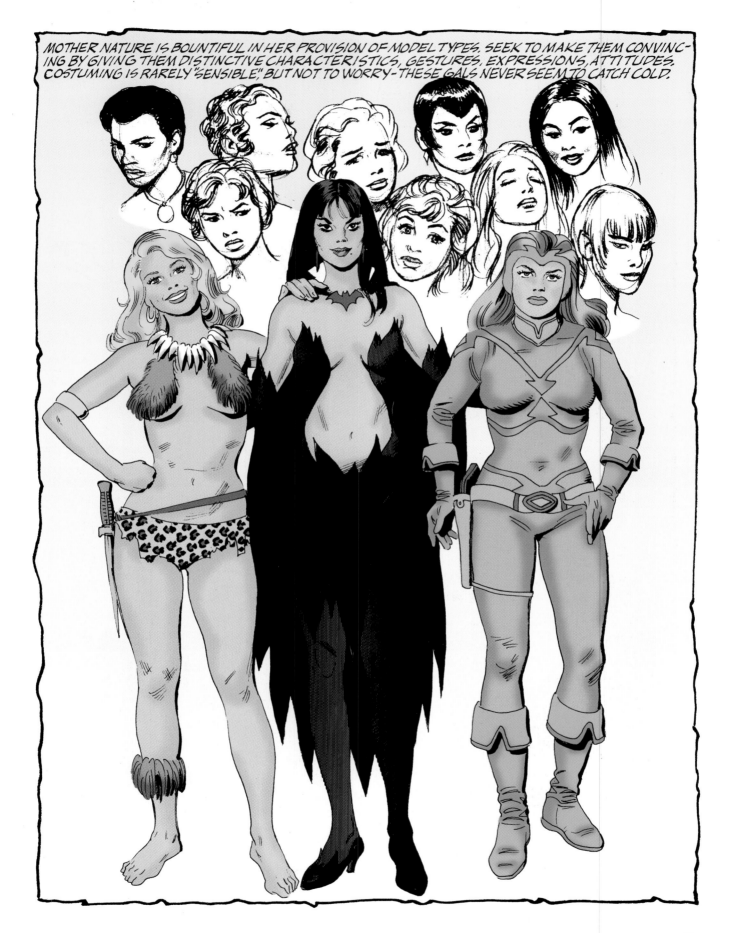

DRAWING FROM PHOTOS

Morrow suggests: "If, for whatever reason, you don't draw from live models, there is a preponderance of photographic references available to study and draw from. This material can be invaluable in solving problems of perspective and foreshortening—and in saving time. Sometimes just 'making it up' can consume hours, and may not even pay off. Use photographs wherever applicable to create your own sirens."

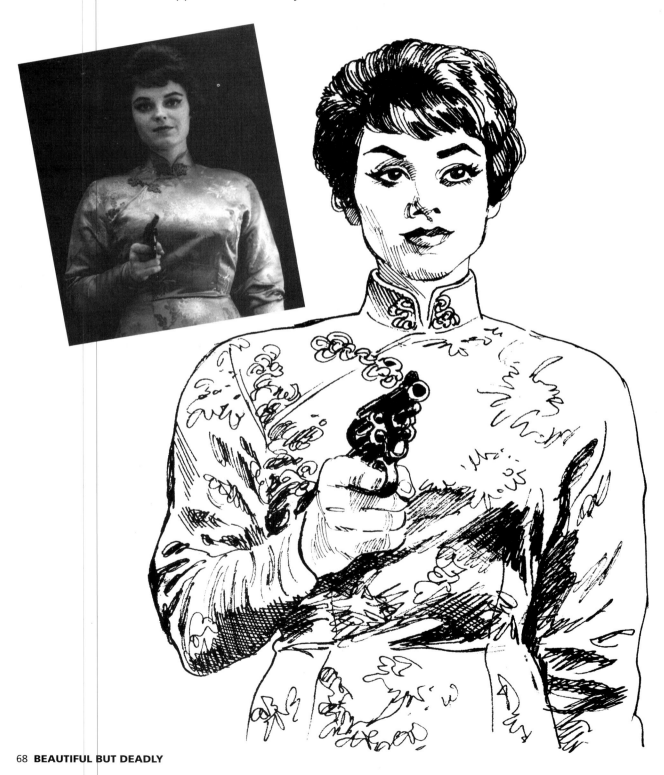

Now let's see how we get there, step by step. Artist Frank Springer approaches the figure by starting rough in an attempt to capture it in sweeping lines.

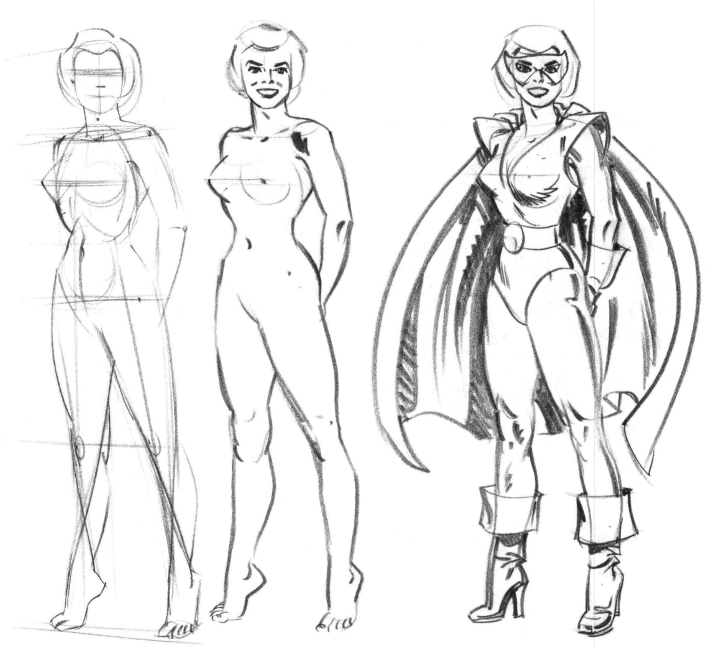

The comic book heroine has a narrow waist, large rib cage, somewhat wide hips (slender hips are less attractive), and muscular legs. Note how the lines that form the hips travel downward to the tops of the feet, giving a pleasing curve to the lower leg. The feet are positioned to allow for her high-heeled boots, which are added later. (Just because she fights bad guys doesn't mean she isn't a fashion plate.) Shoulder flares serve no purpose except to put a little zing in her look. (Remember: In art, form follows function, but in comics, form never follows function!) Even though the cape is flowing, the costume always fits snugly, as if it were painted on. That's why it's so important to concentrate on mastering anatomy. Comic book characters wear extremely revealing costumes. You just can't fake it.

Allow yourself the freedom to sketch loosely while you search for the right form. All the initial work on the body pays off in the final costumed figure, which appears solid and proportional.

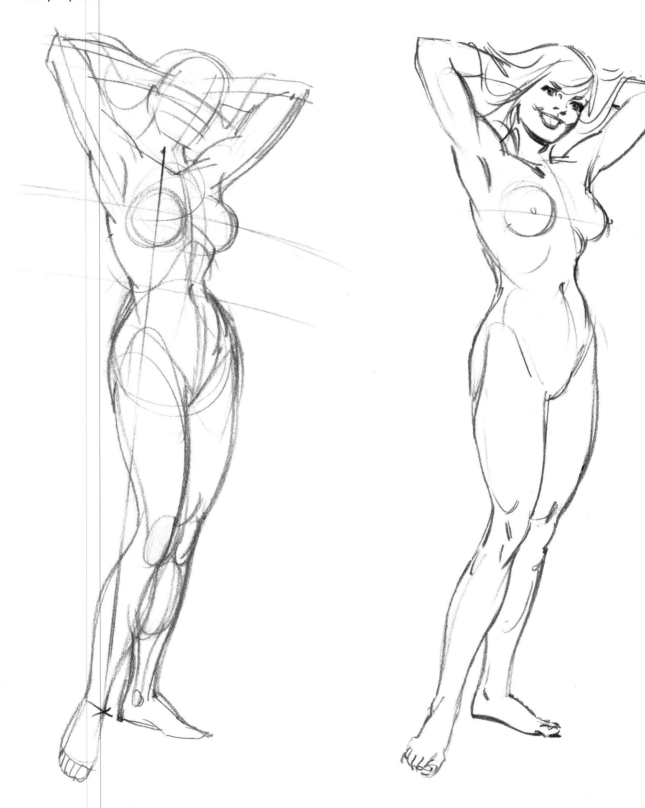

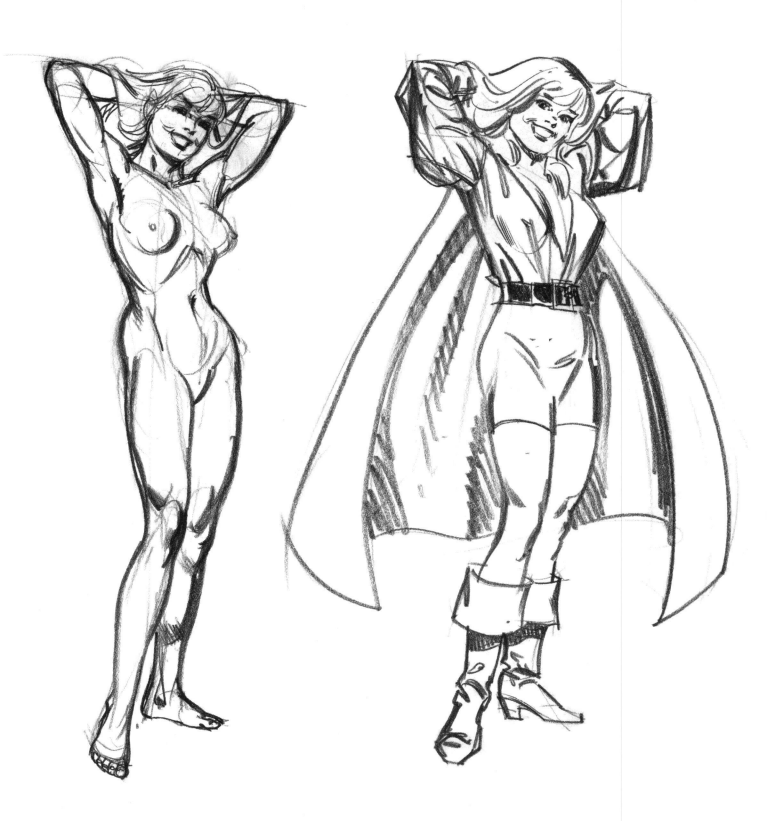

STRONG BUT SEXY

Women with muscles are sexy. But don't overdo it and make your heroine into some massive female bodybuilder. Avoid building up the typical male bodybuilder muscles, like the biceps, triceps, pecs, and lats. Instead, give her overall tone and increased definition and size. Concentrate on her delts and quads.

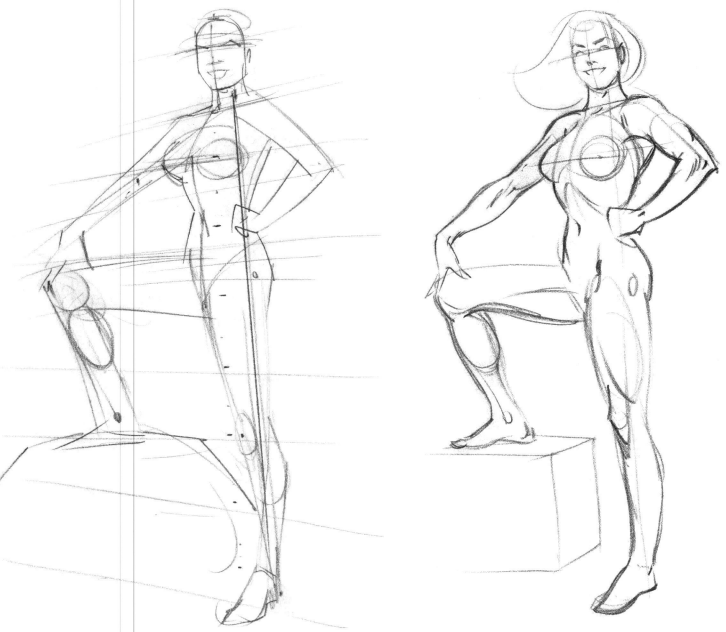

In this sketch, the figure is being conceived with vanishing trace lines. These are the lightly drawn horizontal lines that are sketched across the figure as a reference guide for the artist to draw in perspective. As the figure recedes into the distance (the bent leg is farther from us, and therefore recedes; the straight leg is closer to us, and therefore advances), we must make adjustments for perspective.

You've no doubt noticed how a row of street lights seems to get smaller as it recedes into the distance. The human figure is affected by the same principle, although to a somewhat lesser degree. Objects that recede into the distance start to converge toward a single point, the vanishing point. The figure is being compressed ever so slightly as it recedes, and expanded ever so slightly as it advances. Your characters will become more powerful if you draw them in perspective. (See "Powerful Perspective," pages 76–91.)

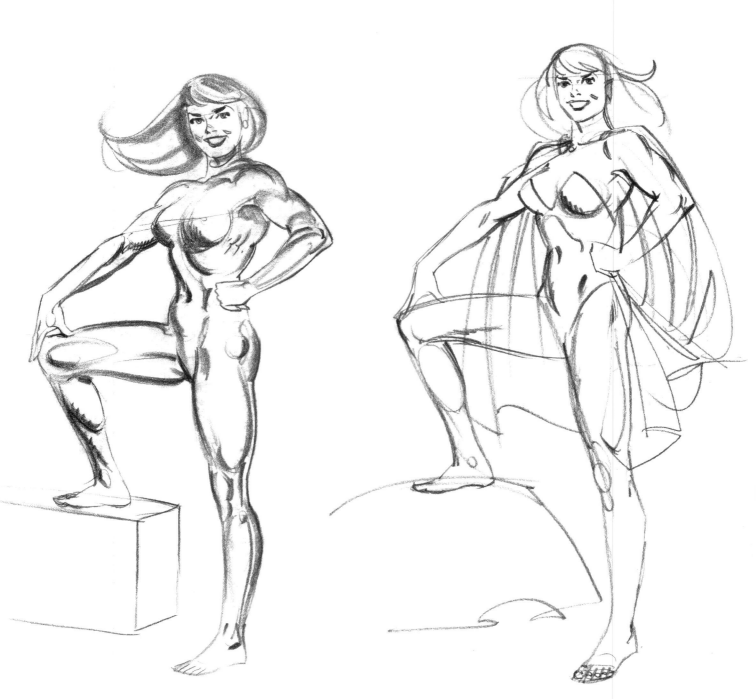

Add contours with darker lines and shading. It's a good habit to define all of the muscles at this stage. Once you costume the figure, you'll want to retain the definition of the "show" muscles and decrease the articulation of others, but you can't make those decisions until you see how the costume actually looks on the character.

The cape hangs like a piece of drapery, folding and curving. It expands as it travels down the body and crushes along the creases.

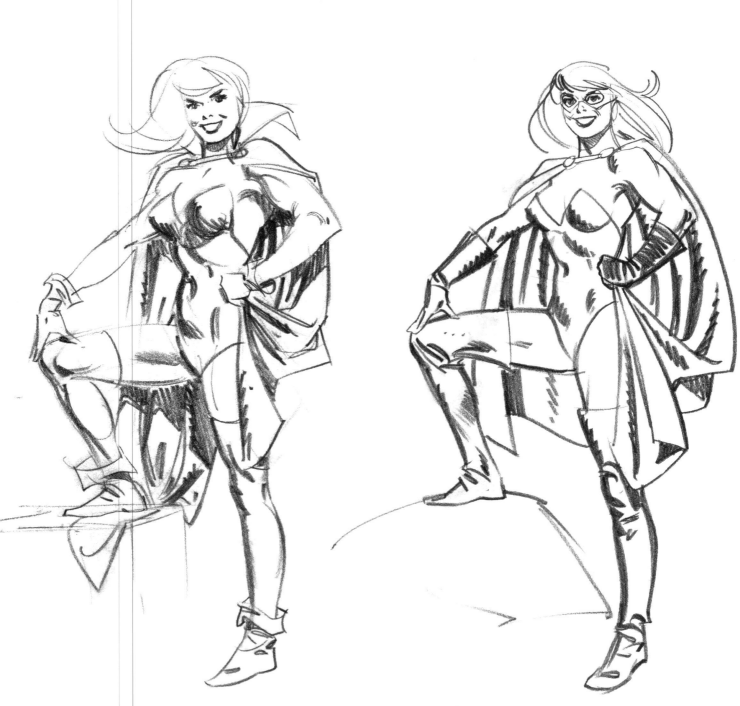

Here is a tighter version of the same drawing with boots, gloves, and short, form-fitting pants. Folds have been added to the cape, and shadows help give a feeling of volume to the form. We've gotten rid of some of the extreme musculature that was used to first construct the body. But the form retains its feeling of strength.

And the final version. It has cleaner, bolder lines. We've added a mask and lost the short pants in favor of mid-thigh boots and long gloves. Now this character is ready for whatever destiny awaits her!

A HINT ABOUT SKINTIGHT COSTUMES

Skintight costumes are popular and easy to draw. The body itself provides the outline for the costume. You only need to draw the lines where the costume ends, as in this example, in which the line of the costume follows the contours of the torso.

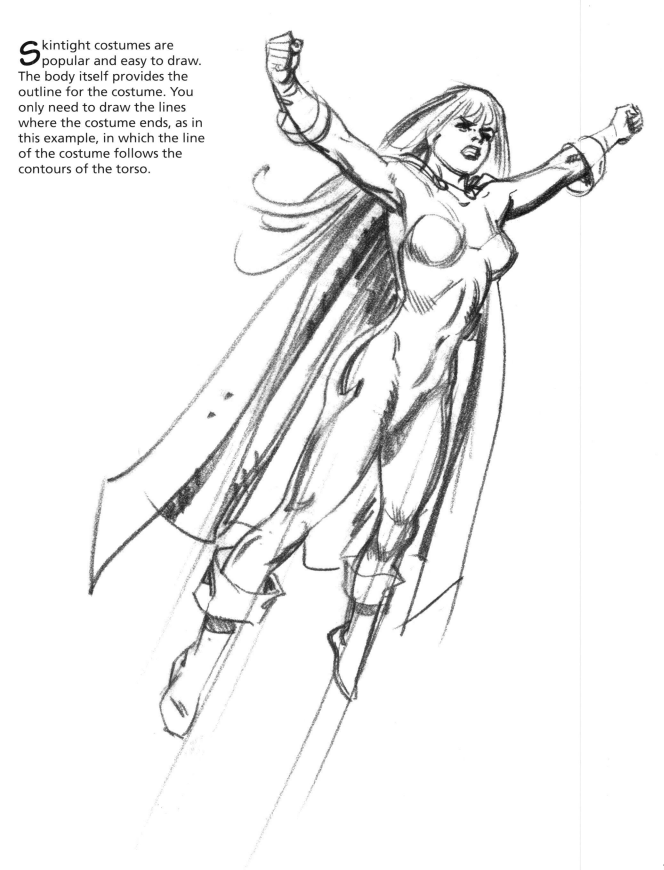

MENTION THE WORD "PERSPECTIVE" and you send chills down the spines of ordinary men. Never fear. This chapter is easy to understand, but even more important, the information in it is easy to use. Remember, we're drawing pictures here, not designing spacecraft. Stay tuned. This will be short and painless.

ONE-POINT PERSPECTIVE

The terms *horizon line* and *eye level* are used to refer to the line of sight that's created from your position in relation to the scene you're about to draw. A drawing uses a system of one-point perspective when all of the lines that recede toward the horizon line eventually converge at one point, which is called the *vanishing point.*

Note, however, that not *every* line converges. The vertical and horizontal lines remain parallel to the frame of the panel. These lines don't converge

because they're not traveling into the distance. They just go up and down, or from side to side. Once you draw a line that appears to travel from the background to the foreground, or from the foreground to the background, you need to use the principles of perspective.

Take a look at the boxes below. Notice how you can extend guidelines to the vanishing point to create the corners *within* a box, which you normally wouldn't see in a finished illustration.

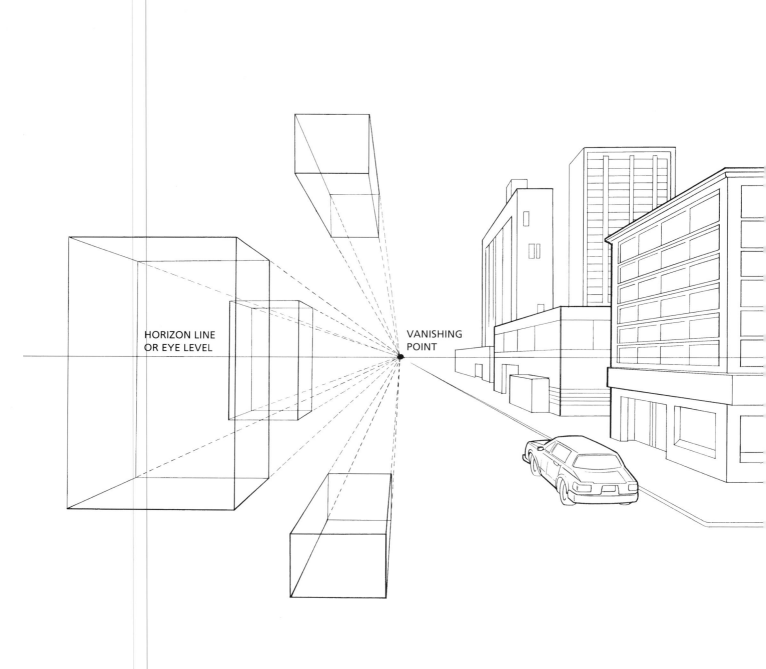

HORIZON LINE
OR EYE LEVEL

VANISHING
POINT

TWO-POINT PERSPECTIVE

Take this quiz: Two-point perspective means that the picture has:

 (a) One vanishing point
 (b) Two vanishing points.

If you picked "a," take a lap, give me ten push ups, and sharpen your pencil. If you picked "b," keep reading.

In two-point perspective, the objects in the picture are not facing forward, but are turned at an angle so that a corner is pointed at the viewer. Because of this, the horizontal lines no longer vanish toward the center of the page as before, but toward opposite ends of the page, to two separate vanishing points. (These can't be seen here because they're too far off to place in the picture.) If you were to extend every line in this picture (except for

the vertical ones) in the direction it's already heading, you'd see that they all converge at either the left or right vanishing point. In illustrations where you want the perspective to appear more gradual, you can place the vanishing points farther away from one another. The closer together the vanishing points are, the more severe the perspective will be.

You'll notice that the horizon line runs horizontally across the picture. It doesn't matter where you place the horizon line; that's just your own personal preference. But once you've established the horizon line's position, the rest of the picture must conform to it. Everything below the horizon line vanishes up, while everything above it vanishes down—toward the left and right vanishing points.

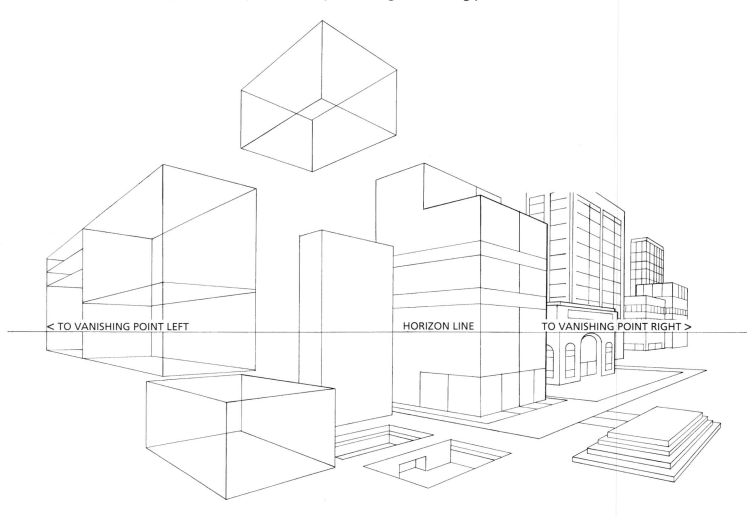

< TO VANISHING POINT LEFT HORIZON LINE TO VANISHING POINT RIGHT >

FINDING THE VANISHING POINTS

Pretty scary-looking, huh? These two scenes may intimidate the ordinary artist, but after reading the preceding page, you can sense the logic behind each one.

The horizon lines are the horizontal ones running across each picture. All figures diminish or increase in size relative to their distance from the viewer. If you have more than one figure in a scene, you've got to draw the ones that are supposed to be close bigger, and the farther ones smaller. Don't give me that bit about how your characters are from another planet where the laws of perspective are different. Cute.

Notice how all of the figures fall within the parameters of the vanishing points. They have to. It's not a choice—it's a law. A physical law. If you break it, you get a metaphysical ticket.

Can you spot the three vanishing points in the illustration at the bottom of the page, and the four vanishing points in the one immediately below?

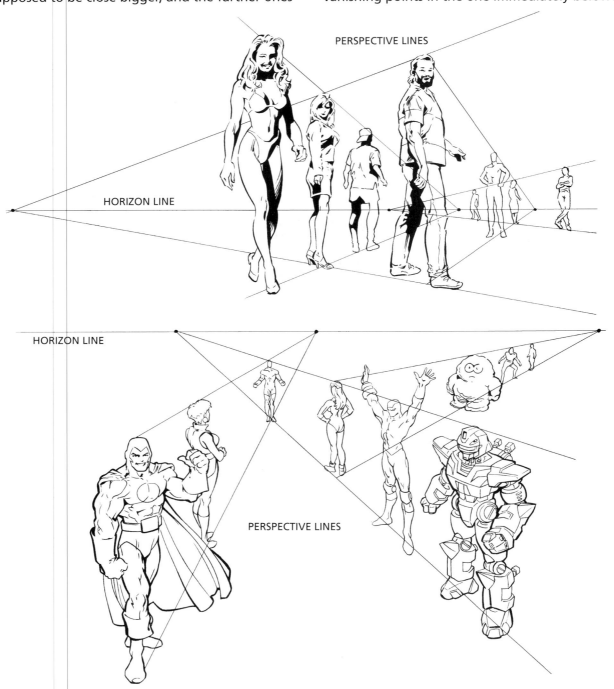

PERSPECTIVE LINES

HORIZON LINE

HORIZON LINE

PERSPECTIVE LINES

THE HORIZON LINE AND THE FIGURE

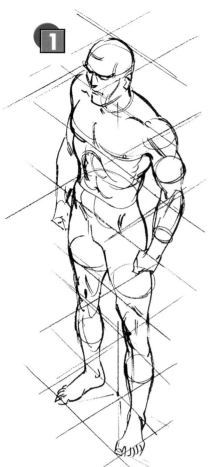

1

2

Where you place the horizon line in a drawing determines whether the viewer looks up at the subject, down at the subject, or straight at it. In other words, the position of the horizon line determines the position of the viewer relative to the picture.

In drawing 1, the horizon line is at ground level, which means that the viewer is positioned above the figure, at a high eye level, which creates the illusion that the viewer is looking down at the figure. The ellipses that are used to indicate the figure's underlying form become wider the lower they are within the drawing. Therefore, the ellipse within each calf is rounder than the one within the chest. Because the vanishing points of the perspective lines would run off the page, a rough grid has been drawn over the figure.

In contrast, a low eye level places the viewer's eye below a figure, which creates the illusion that the viewer is looking up at the figure, as shown in drawing 2. In both examples, the angle of view distorts the figure slightly. In the example at right, the feet and legs appear larger than the head and chest because they are closer to us. In the other drawing, the effect is reversed, so that the head and chest seem larger, and the legs and feet appear smaller.

To determine the proportions of a figure regardless of the location of the horizon line or the eye level, erect a vertical line from the horizon line anywhere along its length. To approximate the points for the top of the head and the crotch, divide the vertical in half. Divide each half in half once more to establish the chest at its broadest point and the position of the knees. A bit of room has been left below the bottom quarter for the feet, which makes the figure slightly taller than 8 heads high—great proportions for a comic book hero.

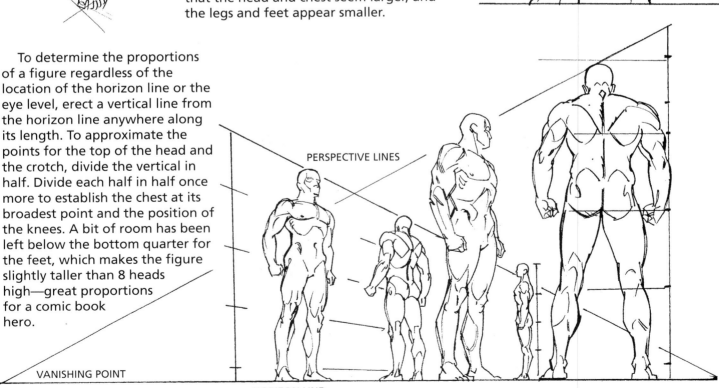

PERSPECTIVE LINES

VANISHING POINT

HORIZON LINE

MULTIPLE FIGURES IN PERSPECTIVE

These four figures are all standing on a level surface. Assuming that they are all the same height, then the horizon line would pass through their bodies at the same point—in this case, their waists. Alternatively, the horizon line could have intersected the figures at the knees, which would lower the horizon line, making the viewer feel that he or she is looking up at the figures.

You have to make slight adjustments when drawing short figures or figures not on the same flat surface. "Eyeball" it—if it looks right, it's right. If a figure looks like he's "floating," he's too high. Lower him, or, as many artists do occasionally, draw a step under him.

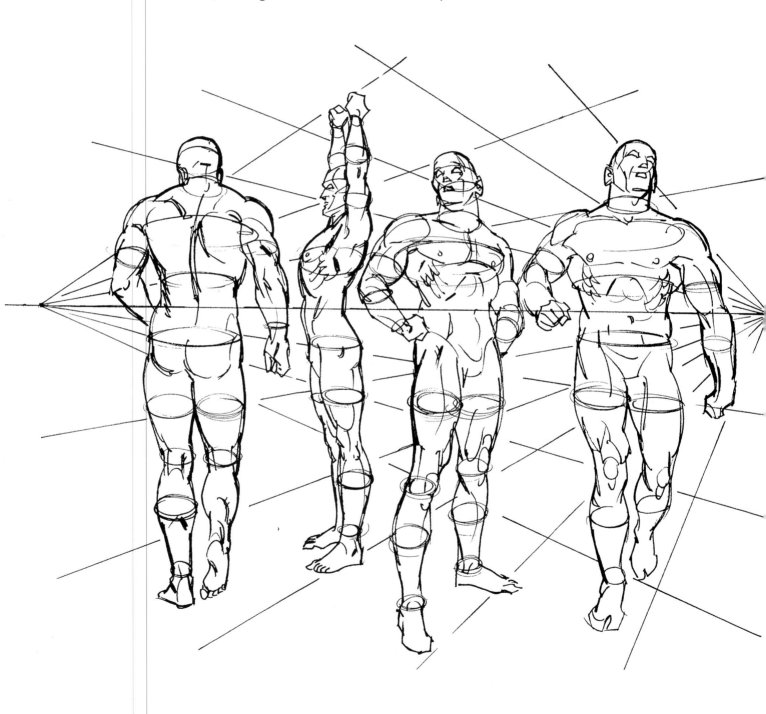

HANGING FIGURES ON A HORIZON LINE

This is an artist's trick for keeping all the figures on the same ground plane. When you place figures in detailed backgrounds, you have to use vanishing points to indicate perspective. But if there's an open background in a single color, or a background with no hard edges in perspective, such as sand dune, an open field, or just a wall with only straight vertical and horizontal lines, then you can use this technique.

You can align the figures at any point. In this drawing, they're aligned at the eyes. This assumes that all the figures are generally the same height and on even ground.

HORIZON LINE

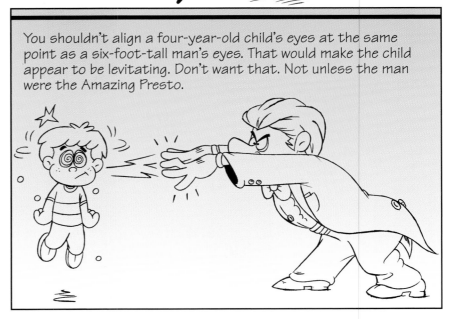

You shouldn't align a four-year-old child's eyes at the same point as a six-foot-tall man's eyes. That would make the child appear to be levitating. Don't want that. Not unless the man were the Amazing Presto.

CREATING VOLUME WITH PERSPECTIVE

The human body exists in the real world, and, as such, is subject to its immutable laws: Everyone pays taxes, everyone hates gym class, and everything diminishes in size as it travels away from you (toward the vanishing point[s]). If you were drawing a railroad track, you would doubtless draw it so that it appears to diminish in size as it travels into the distance. But when people draw figures, they somehow think that the laws of perspective don't apply.

Not so. In fact, there is no more necessary application of perspective than on the comic book figure. Perspective creates much more dynamic, powerful-looking characters. You don't need a lot of perspective for the body; just a little will give your drawings that added air of professionalism. Because the body doesn't cover as much distance as a road, a slight suggestion of perspective will be effective.

To find the perspective points on a figure, it's useful to create a mannequin made out of blocks. These blocks have straight lines that can be followed toward a vanishing point in the distance. Each block has dimension—sides, if you will. They're not flat. Remember that everything has a side to it. Even a cylinder, which is rounded, has a "side" that appears closer. Next time you draw a rib cage, remember that you're not just drawing a chest and a back; you're also drawing the *sides* of the rib cage, which you can shade to create depth and dimension.

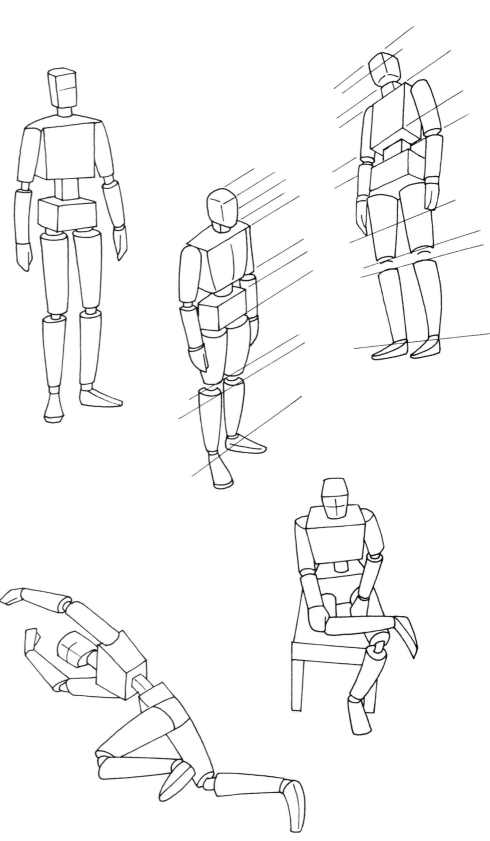

DYNAMIC ANGLES

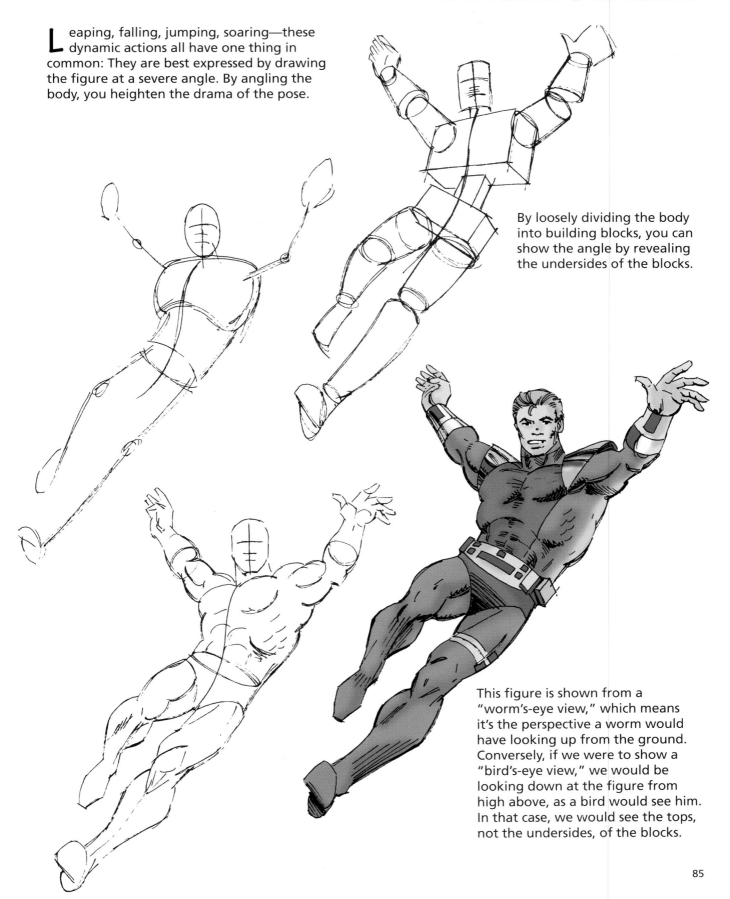

Leaping, falling, jumping, soaring—these dynamic actions all have one thing in common: They are best expressed by drawing the figure at a severe angle. By angling the body, you heighten the drama of the pose.

By loosely dividing the body into building blocks, you can show the angle by revealing the undersides of the blocks.

This figure is shown from a "worm's-eye view," which means it's the perspective a worm would have looking up from the ground. Conversely, if we were to show a "bird's-eye view," we would be looking down at the figure from high above, as a bird would see him. In that case, we would see the tops, not the undersides, of the blocks.

FROM START TO FINISH

Now let's build a figure using vanishing trace lines as guides along various planes of the body.

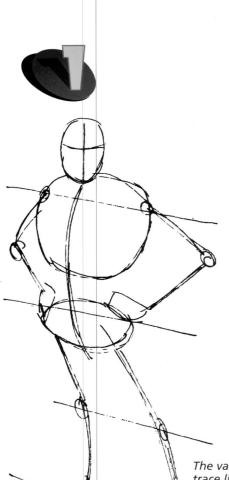

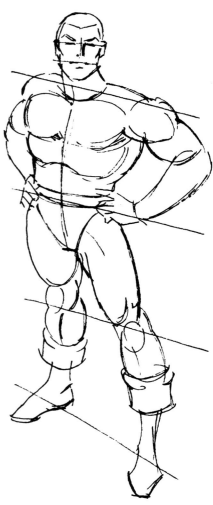

The vanishing trace lines (and you can use more) are along the collarbone, pelvis, knees, and feet.

Using rectangles and cylinders, construct a body in perspective.

Once you flesh out the form, the rectangles and cylinders can be erased, but the foundation of perspective will remain solidly in place. Many beginning artists leave out the first three steps and start at step 4. The body may have all these great-looking details on it, but the perspective will be wrong, and its impact will be undermined. Look how much stuff we've already covered by the time we've gotten to this step. Costuming this guy should now be as easy as falling off a log. But to the person who doesn't know about drawing in perspective, this step will be a struggle, as he or she "guesses" how to make the figure look right.

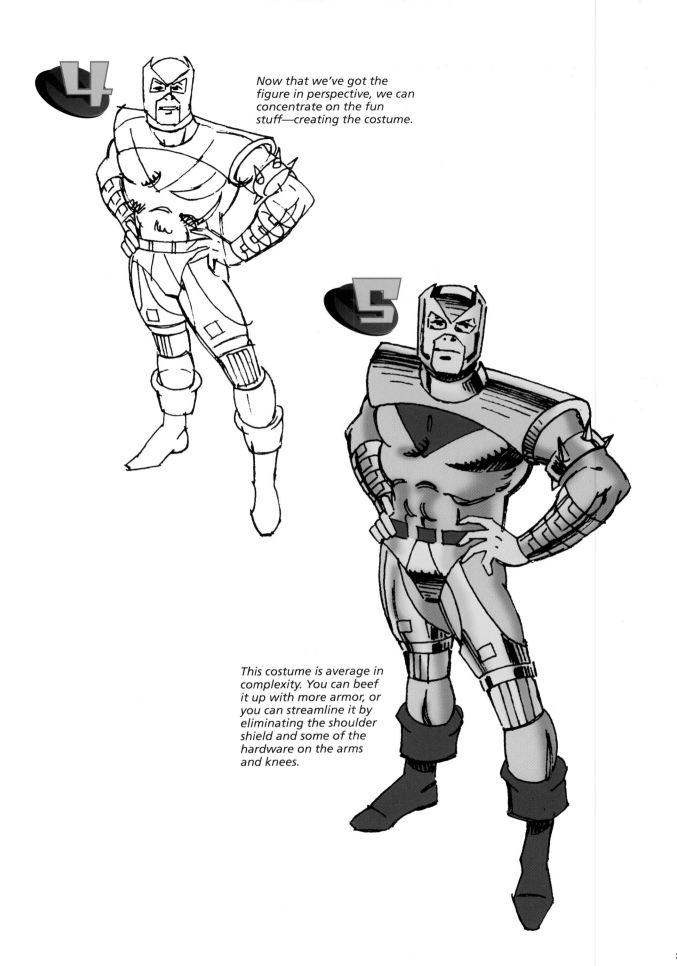

Now that we've got the figure in perspective, we can concentrate on the fun stuff—creating the costume.

This costume is average in complexity. You can beef it up with more armor, or you can streamline it by eliminating the shoulder shield and some of the hardware on the arms and knees.

EXTREME FORESHORTENING

Comic book illustrations are famous for their use of extreme foreshortening. *Foreshortening* is the way an artist makes an object look like it's coming straight at you, but without making it look like it's flattened out. It's a powerful tool at the artist's command.

Gray Morrow points out that foreshortening makes the figure "seem to jump right out of the page. It is difficult to make this effective and, at the same time, believable, because you're attempting to give the impression of three dimensions in a two-dimensional medium."

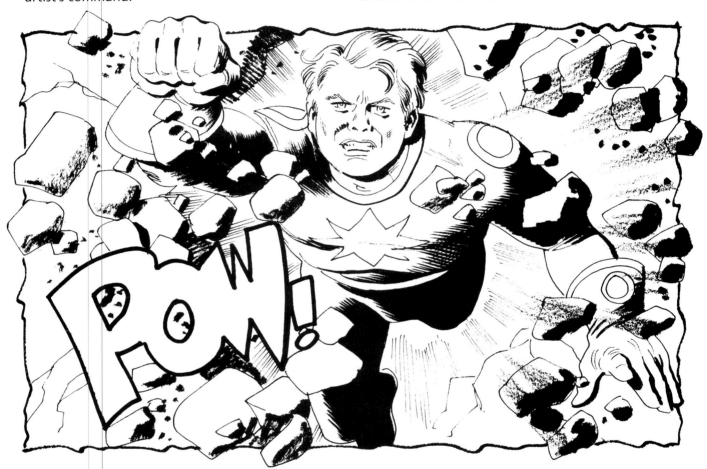

To create the illusion of depth, layer one form on top of another, showing the overlap, and thus tricking the eye into seeing the overlapped shapes as being further away. Always draw general shapes first when building the foreshortened figure. If you go to a finished drawing right away, you'll get stuck in the details, and lose the layering concept.

FORESHORTENING IS A SUBJECT THOROUGHLY COVERED IN A GREAT SELECTION OF BOOKS ON ANATOMY WIDELY AVAILABLE. HOW TO USE IT IN COMICS WILL BE OUR MAIN CONCERN HEREIN. THERE ARE MANY INSTANCES IN A STORY WHERE THE ACTION CAN BE POINTED UP TO A GREATER ADVANTAGE. PERHAPS THE FOREMOST IS...THE PUNCH....

TELLS THE STORY, REASONABLY ACCURATE BUT FRANKLY STATIC....

...NOW WE CAN SEE THE MISCREANT IS REALLY BEING KNOCKED INTO THE MIDDLE OF NEXT WEEK!

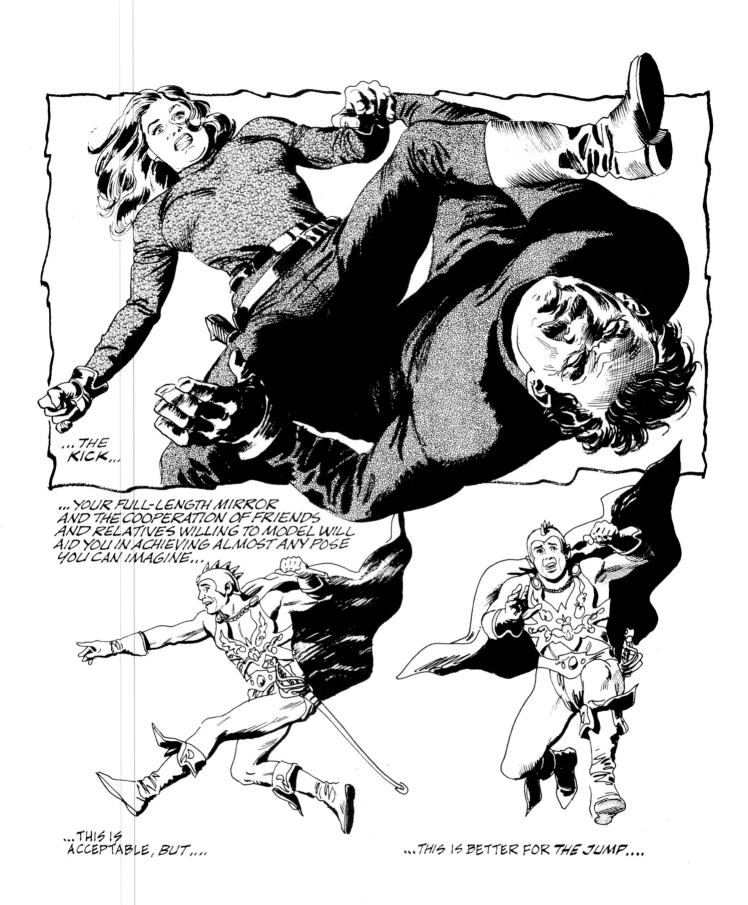

...THE KICK...

...YOUR FULL-LENGTH MIRROR AND THE COOPERATION OF FRIENDS AND RELATIVES WILLING TO MODEL WILL AID YOU IN ACHIEVING ALMOST ANY POSE YOU CAN IMAGINE...

...THIS IS ACCEPTABLE, BUT....

...THIS IS BETTER FOR *THE JUMP*....

A SUB-TITLE FOR THIS CHAPTER MIGHT BE—"COMIN'ATCHA" OR MORE PROPERLY, P.O.V.,(POINT OF VIEW). WITH YOUR CAMERA EYE YOU CAN PLACE THE READER/VIEWER JUST AS A FILM DIRECTOR DOES, IN ALMOST ANY POSITION THAT WILL ACCENTUATE THE ACTION TAKING PLACE.

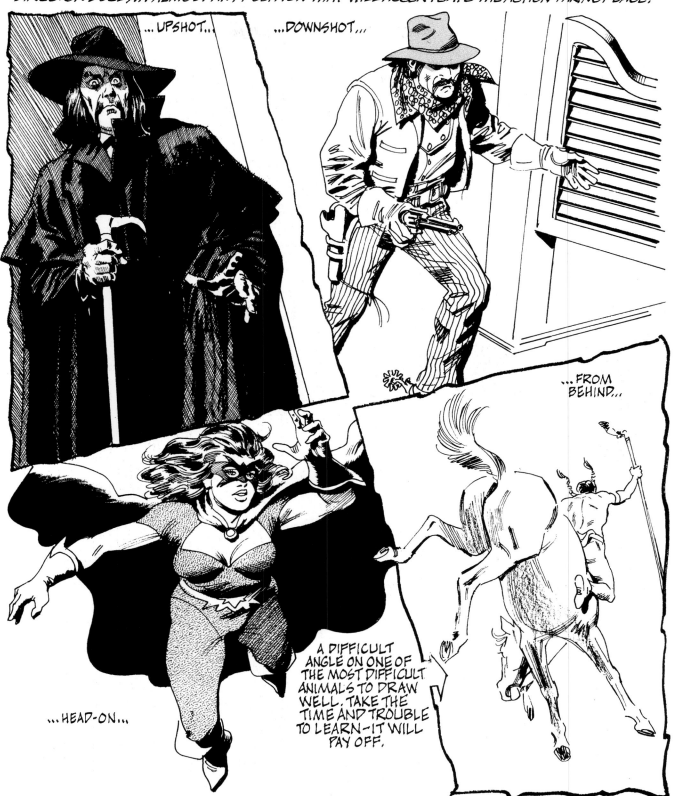

...UPSHOT...

...DOWNSHOT,...

...FROM BEHIND,...

...HEAD-ON...

A DIFFICULT ANGLE ON ONE OF THE MOST DIFFICULT ANIMALS TO DRAW WELL. TAKE THE TIME AND TROUBLE TO LEARN—IT WILL PAY OFF.

THE SHAPES OF THE PANELS THEMSELVES, THE WAY YOU BREAK UP THE PAGE, CAN HELP YOU DETERMINE THE P.O.V. AND AMPLIFY YOUR DESIGN OR COMPOSITION.

THE BIG BANG!

Y OU NEED THEM TO DRAW EXPLOSIONS. You need them to draw fight scenes. You need them to draw weapons that are firing. And you need them to draw those fantastic spreads that depict colossal action or emotion. What are they? Patterns of energy, visually elegant yet powerful abstract designs that convey mood and impact. These are important tools in your growing arsenal of professional comic book techniques.

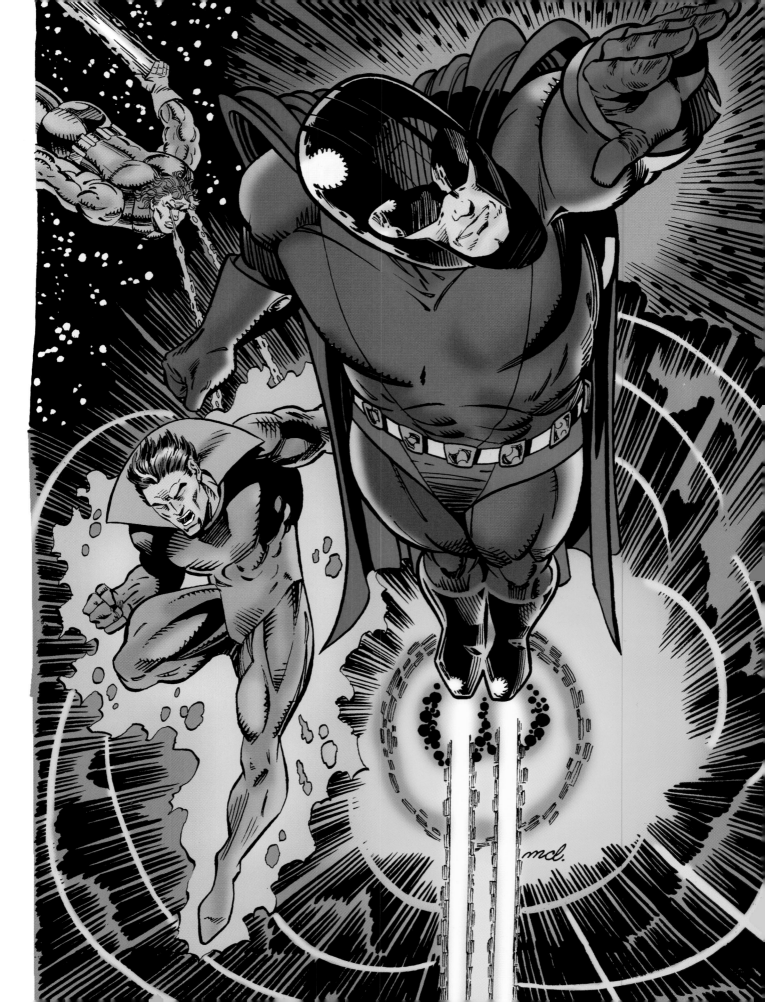

USING PATTERN AND VALUE

Comic book artists use patterns to create shading, backgrounds, explosions, space goo, and to decorate empty areas of a page.

Let's say that each pattern is a specific *value,* or degree of lightness or darkness. We'll talk about these as percentages, 0% being pure white and 100% being jet black. Unless you're depicting a gradual transition from light to dark, patterns that appear side by side should always be at least three value steps apart. For example, you could put a 20% value and a 50% value next to each other, or a 30% value and an 80% value. But *not* a 20% value and a 30% value. Because these values are too similar, there isn't enough contrast, and the patterns would blur together. Notice how the three bars above, left, appear confusing to the eye. That's because their values are too close to each other. But the six bars above, right, are all distinct because the value of each one is quite different from the one next to it.

This is very practical stuff you're learning. If you draw a character in front of a building, you now know that they have to be shaded with values that are somewhat far apart, or they'll blend together.

At right are examples of established comic book patterns. But don't stop there. You can make up your own. Keep in mind that your drawings will be reduced to fit on a comic book page, so don't draw the lines of any particular pattern too close together or they'll reproduce as an indistinct mass.

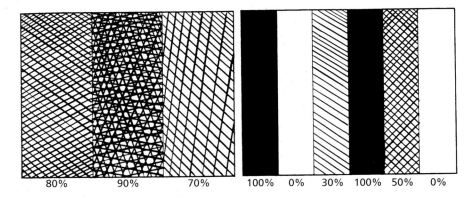

80% 90% 70% 100% 0% 30% 100% 50% 0%

Values

PARALLEL LINES
(20% VALUE)

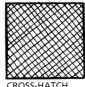

CROSS-HATCH
(40% VALUE)

CROSS-HATCH
WITH VERTICAL LINES,
(TRANSITION FROM
LIGHT [40%] TO
DARK [60%] GRAY)

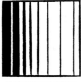

GRADED LUSTER
(100% TO 0%)

GRADED SPATTER
(100% TO 0%)

GRADED STROKES
(70% TO 0%)

RANDOM
CIRCULAR PATTERN
(10% TO 20%)

VINTAGE
CROSS-HATCH (30%)

SCALES
(10% TO 20%)

PARALLEL WAVES
(40% TO 60%)

ROWS OF
PARALLEL LINES
(40% TO 50%)

RANDOM CLOUD
SHAPES (10%)

SPECIAL EFFECTS IN SPACE

If you're a normal person, you probably think of space as vast emptiness. If you're a comic book fan, you know that space is filled with eerie visual effects, unnatural forces, and bizarre energy patterns. Feast on these examples:

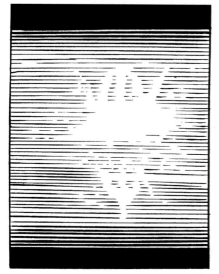

ENERGY WAVES
Draw or paint parallel horizontal lines, then erase or paint in white whatever you want the pattern within the lines to be. You can also spatter the lines with white paint for a random effect.

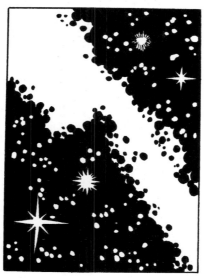

MILKY WAY
The jagged borders of the black void are flecked with black bubbles. Within the black areas, randomly add stars with white paint. Group the stars instead of spacing them evenly, and brighten a few with large twinkles.

GALAXY EFFECT
Another version of the Milky Way, but with elliptical instead of round shapes. A funnel effect creates a feeling of movement.

MYSTICAL COMIC EFFECTS
Unearthly shapes and spheres for strange or weird stories.

ALIEN SPACE FORCE
A crystalline force radiates intense energy illustrated with randomly painted thin white lines across black ink lines.

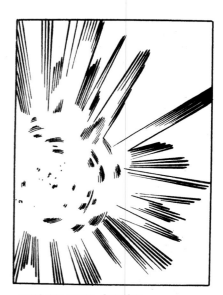

SPACE EXPLOSION
In contrast to an earth-bound explosion, a space explosion expresses pure energy without any haze or smoke—because there's no oxygen in space. Despite the force of the blast, its center remains spherical.

BURSTS

The special effects of yesteryear were sedate compared with the galactic-sized bursts that reverberate throughout comic books today. Bursts are used in fight scenes, to herald the sudden appearance of a powerful figure, to express impact, to draw attention to whatever is at its center, and to illustrate explosions. They add energy, convey action, and create the illusion of motion.

Many, but not all bursts, include tiny bubbles. A black background provides maximum contrast for the burst's tiny bubbles, which can be difficult to see in color against a colored background. But if the bubbles appear against a black background, the colorist just adds color to the whole image.

Related to the burst is the mind-numbing explosion (shown on the opposite page). This earthly blast exhibits certain hallmarks: Debris flies out of its center, smoke in various shades billows across the scene, and its very center is white, indicating extreme heat. Its surrounding rings—from yellow, to orange, to red at the blast's periphery—show a gradual decrease in heat.

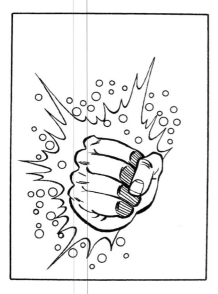

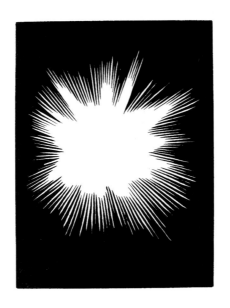

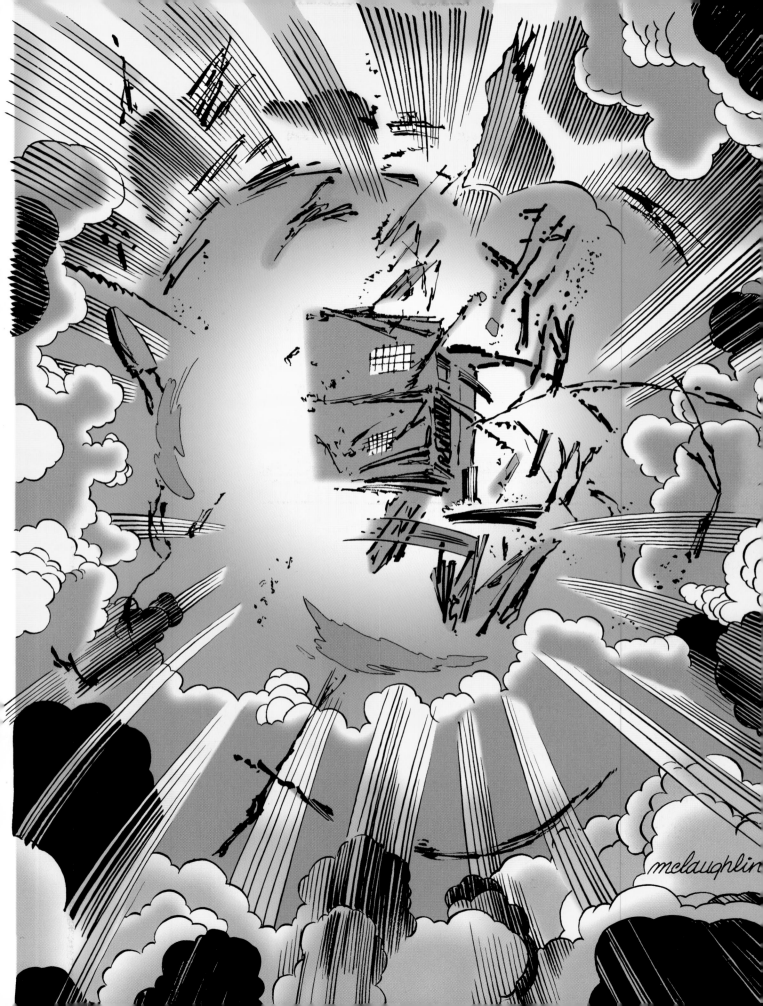

PUTTING IT ALL TOGETHER

In this wonderful illustration, artist Frank McLaughlin has used all of the elements that are covered in this chapter. While the figures and faces in the drawing don't display a lot of action, the special effects create an explosive feeling, as if the entire image were in motion.

THE PLOT THICKENS

WHAT WAS THE BEST STORY YOU EVER HEARD?

My favorite is a supernatural tale of good versus evil that was told by a camp counselor as a group of us sat, enthralled, around the fire. Every word he uttered conjured up an image that created a feeling of urgency. As an artist, that's the kind of life you want to breathe into a comic book script. You want your readers to be captivated by every image. It can be done....

EFFECTIVE COMPOSITION

The secrets of effective composition are shared among professionals but are rarely found in how-to books. Yet, these rules are essential if you want to create powerful images. You can render the most exquisite drawing, but if the figures aren't positioned well in relationship to each other, the reader, the background, or the panel that frames the scene, then it won't have the impact you're striving for. Don't rob yourself of the effect you've been working so hard to achieve.

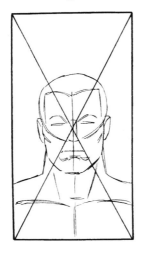

DON'T!
...put the dominant element in the center. It's just not dynamic.

DO!
...divide a panel by three both horizontally and vertically, for a total of nine equal sectors. This is a painter's and illustrator's trick for creating dynamic compositions, and it's worth the price of the book alone.

DON'T!
...cut off corners. It's a sign of an amateur. Instead of making the picture more interesting, you've succeeded only in making triangles in the corners of the panel. Less tilt would actually make the drawing more dramatic.

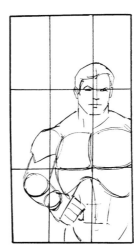

DO!
...place the center of interest at any point where these lines intersect. In this case we've placed the hero's head at the intersection of the right vertical and top horizontal guidelines.

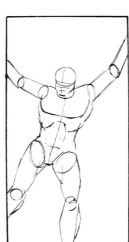

DON'T!
...cut off hands and feet. What it tells the reader is, "Oh, this guy can't draw hands and feet."

DO!
...vary your compositions. This is a longer shot using the same principle, but whose point of emphasis falls at the intersection of the left vertical and top horizontal guidelines.

The establishing shot does just that: It establishes a scene or the positions of different characters by showing them from a distance where everything and everybody is visible. If you didn't have an establishing shot and used only close-ups, before long the reader would be lost and unable to identify the context in which the scene takes place. On the other hand, too many establishing shots make a story remote and inaccessible because the reader is kept at a distance from the characters.

An establishing shot doesn't always have to be at the beginning of a story, although that's usually the case. Sometimes an establishing shot, like the one below, is used in the middle of a story to "widen it out" and let it breathe. You might be illustrating dialogue that takes place in an office, but an office interior can become claustrophobic, so you cut to the exterior of the office and show the city to give the scene some breathing room. In the example below, the exterior is a futuristic city. This professional technique breaks up the monotony and helps to keep the reader's interest.

Notice how the dialogue balloons appear to be coming from the office building, but their spouts aren't coming from any particular window. They simply indicate that the dialogue is coming from the general area of the office, and the point comes across clearly.

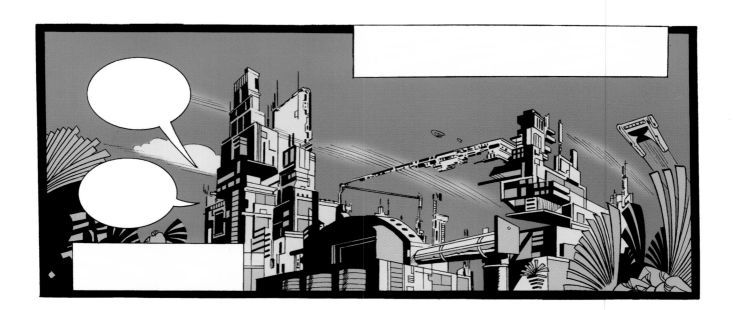

WHAT A COMIC BOOK SCRIPT LOOKS LIKE

Each comic book script is different. While some writers offer lots of descriptive detail, others provide very few clues as to how a scene should look. The role of the comic book penciler is part interpreter, part creator. He or she must find the most exciting and effective way to tell the story.

HERO VERSUS VILLAIN/SPECIAL ISSUE, VOLUME III

PAGE 4

Our Hero reels in agony as the huge, other-worldly villain shoots a cable around his neck, strangling him. Hero grabs knife from his belt and slashes the cable, breaking free. He is now one ticked off guy. He's ruffled, not the smooth, untouchable fighter we are used to seeing. The Hero gives Villain his famous glare of bad intentions.

If that won't kill the Hero, this will: with his free hand, the Villain quickly pulls out a heavy gun that FIRES four missiles all at once! The missiles race toward our Hero.

Hero leaps into the air - and I mean acrobatics - just as the missiles explode at the exact point where he **was**.

Hero suddenly spins, and with a solid two-handed grip, fires his blaster into Villain's body. Villain is right behind Hero, one more moment, and Hero would have been Spam. A huge explosion fills the panel. Villain is blown back -- the weapon goes flying out of his hand. Nothing could survive that.

PAGE 5

Hero slumps to his knees, in the middle of the city street. Villain lays next to him, face down, gone. Hero is exhausted. Crowds peer. Life coming back to the street. Hero whispers: "It's over..."

Villain's arm lays dormant as we see the Hero walking away in the background.

The Hero gets on his motorcycle, kick starts it and it hums. He looks at a kid who is looking at him. Kid says, "Gee mister, I thought you was gonna get killed."

Hero says, "Thanks for having so much confidence in me."

Kid says, "Do you think you could beat him if you fought him again?"

WE SEE THE VILLAIN'S FINGER TWITCH. The fat lady didn't sing yet.

Hero says, "Why do you want to know that?"

Kid says, "Because he's right behind you!"

And with that, the Villain rises, grabs the motorcycle the Hero is sitting on, and hurls him into the side of a building!

PACING

is also important. If every panel is an explosion, then the reader will become weary after a few pages, and the explosions will lose their "pow" (pardon the pun).

When a penciler starts laying out a page from a script—in this case, page 4—he has many options. He begins by sketching a variety of approaches without committing to any. Some he'll save, some he'll combine, and some he'll tear up into teensy little pieces.

Thumbnail sketches are small, quick sketches that show the sequence and general direction of a series of images. It's very important that you don't fall in love with your thumbnail sketches. This would defeat their purpose, which is to give an artist the freedom to throw them away or change them. You're seeking ideas at this point, not finished drawings.

The approach above, left, doesn't show enough of the characters' faces to make the action compelling.

The approach above, right, has wonderful dramatic angles. But the characters are still too far away to pull us into the story.

The approach at right combines medium shots and close-ups with a variety of interesting angles. It's a keeper.

THE ROUGH LAYOUT

Once the penciler decides on the best way to approach the script, he begins the rough layout. The most significant part of this stage is to evaluate the general feeling of the page. Does the story flow, or does it seem like random panels jumbled together? Is it dramatic, or does it meander from picture to picture? Are the images within each panel clear or cluttered? Does the largest panel contain the most important action? Notice how a heightened sense of urgency is achieved by alternating close-up shots with full shots, as well as by alternating the angles. We're either looking up at someone or down at someone, but rarely are we looking at them head on. Also notice that the panels vary both in dimension and size. Variety keeps readers on the edge of their seats.

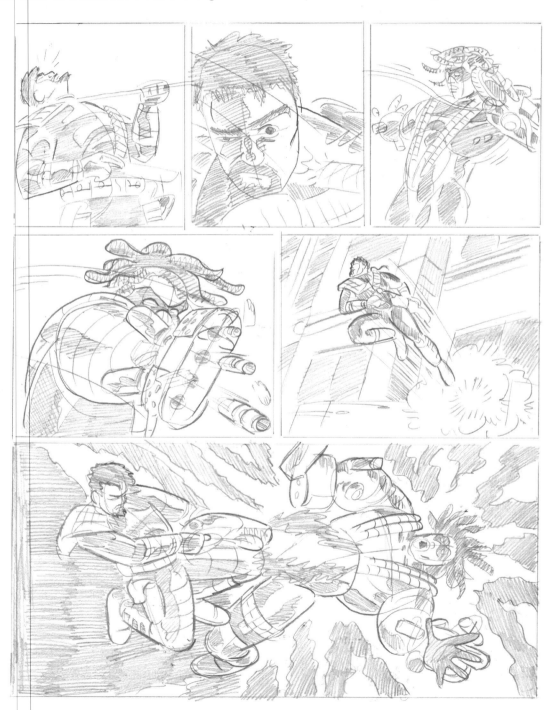

PREPARING A PENCIL LAYOUT FOR INKING

After the rough layout, the penciler starts to work "tight." This means that everything must be precise, because the inker, who works on it next, can't read the penciler's mind. If a line is missing, the inker may not put it in. If a sloppy line is there, the inker might ink it anyway. So the page should be perfect. Now is the time to work on the details. This is when it really counts.

Notice how much care is taken to save room for the large inked areas. Black areas add weight and melodrama to a scene and create contrast when juxtaposed with white or light colors. Note also the striking negative (white) space among the billows of black smoke in the bottom panel. An experienced penciler works to create such areas for the colorist, who can have a field day with them.

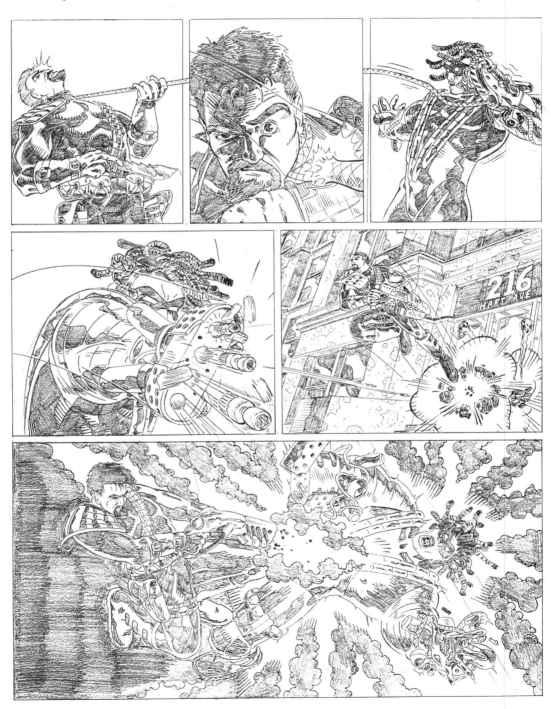

THE FINAL INKED PAGE

Inking is a tremendous skill. Professional pencilers know how valuable a good inker is, and they actively lobby the publisher to get the best inker to ink their pencil drawings. The inker does more than just trace pencil lines in ink. He gives them shape and crispness. He is also constantly on the alert, making sure that drawings read clearly in terms of lights and darks. In doing so, he may make small adjustments to the pencil drawing. The following are some of the flourishes that Frank McLaughlin, known for his deft pen work, has made to Alexander Morrissey's excellent pencil drawings.

Textural detail was added to the whip, and a touch of white was added to the character's beard for contrast.

Frank added a burst of energy around the character to heighten the urgency in the scene.

The cartridges around the missiles were left out because the image was sharp and effective without it.

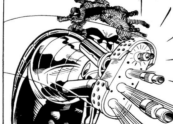

The buckles on the hero's boots are rendered in white and black. If they were left black, they would blend into the black background.

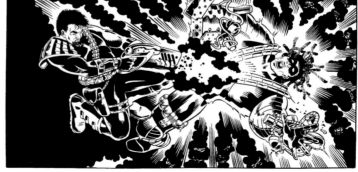

Burst lines were added between the clouds of smoke to fill in the page.

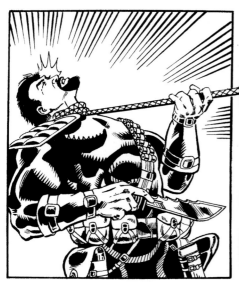

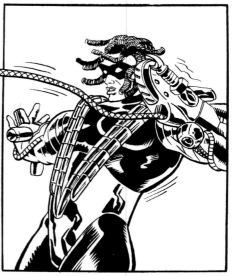
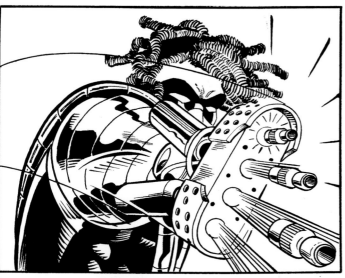
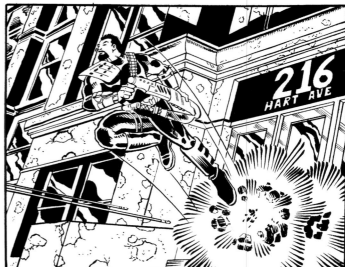
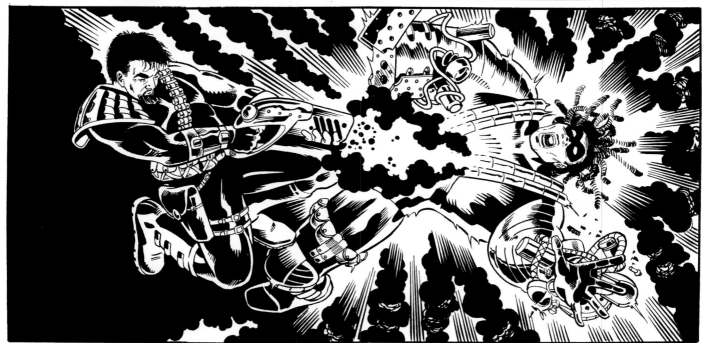

THERE ARE CERTAIN SKILLS that can't be mastered unless you're working in the comic book field. That's because these techniques don't fit neatly under one category, but instead are acquired over the course of a career. These techniques are usually shared over coffee with fellow cartoonists, as everyone discusses what they're working on. If you were there at that table, at that diner, this is what you would have overheard….

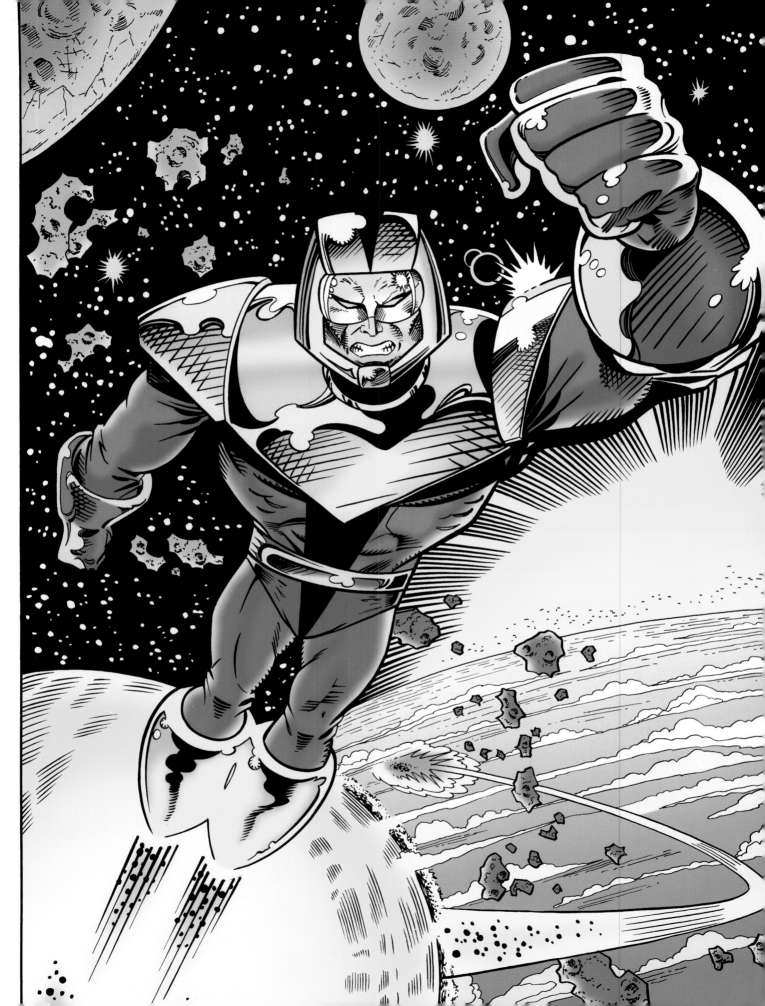

INKING LIKE A PRO

Many people break into the business by inking other people's pencils, so it's important to at least acquaint yourself with the subject. But inking is an art in itself. Even the most dramatic comic book illustrations can achieve their full impact only when a talented inker adds his magic. The ink line has a crispness, boldness, and variety of thickness that a pencil line can't produce. As shown in the illustrations at right, there are three basic types of ink line. By varying its thickness, we get bolder or softer lines. Just using one thickness of line leaves a character looking lifeless.

The magician's adage "It's all in the wrist" also applies to inking. The more you bend your wrist, the less control you'll have. Of course, the line will remain straight up to a point. But when you bend your wrist too much, the line becomes wobbly. The solution is to keep your wrist *locked*, your hand *loose*, and move your whole *arm* instead. With a little practice, it'll become second nature to you.

A few more points: Hold the pen or brush straight up and down. Feel free to move the page around, so that your arm is always at a comfortable angle.

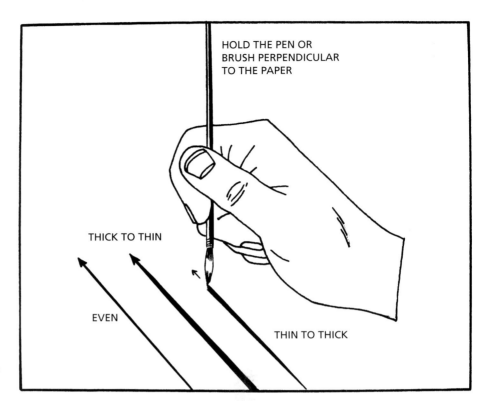

HOLD THE PEN OR BRUSH PERPENDICULAR TO THE PAPER

THICK TO THIN

EVEN

THIN TO THICK

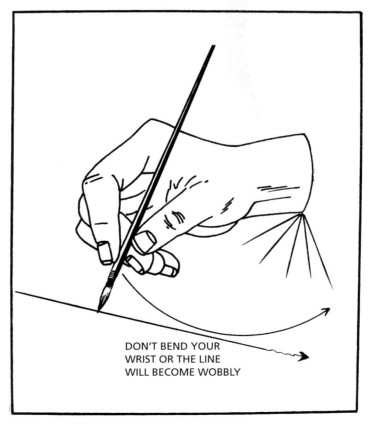

DON'T BEND YOUR WRIST OR THE LINE WILL BECOME WOBBLY

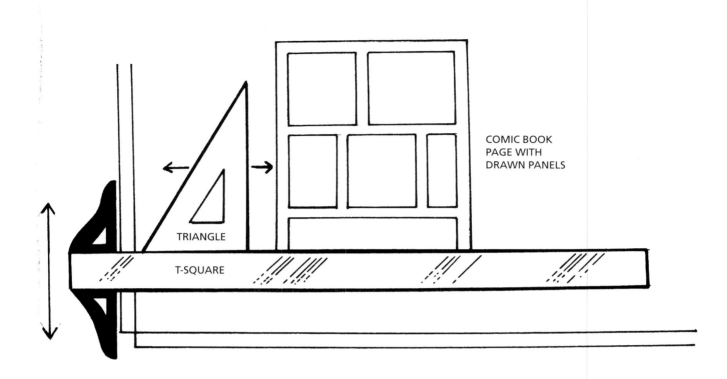

COMIC BOOK
PAGE WITH
DRAWN PANELS

TRIANGLE

T-SQUARE

Doesn't a T-square look serious? But hey, if comic book artists use one, how complicated can it be? It's a great tool. You'll actually like it when you use it. Scary thought. All horizontal lines are drawn with a T-square; all vertical lines are drawn against a triangle. This eliminates the fuss of measuring.

Lucky you. Just when you were wondering when we were going to get back to this subject, here it is again: more gray tones! In black-and-white drawings, tones are created by adding shaded sheets that come in various percentages of gray. If you look closely at a newspaper image, you'll see that the shades are all made up of black dots called *screens.* The bigger and closer together the dots are, the darker the shade. After your drawing is finished, carefully cut a sheet of screen so that the piece fits precisely within the area to be shaded, then burnish it down.

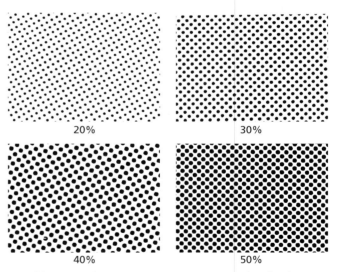

20% 30%

40% 50%

In addition to drawing your own patterns for shading, you can use screens.

ART SUPPLIES SHOPPING LIST

You don't have to commit this stuff to memory. Just bring this book into any art store and the salespeople will help you find the items you need. Before you purchase any art materials, check the labels to make sure they're nontoxic. You shouldn't buy or use anything that has a warning label on it. Use only nontoxic inks and materials with all the instruments listed in this chapter.

The brush preferred by many inkers is the Winsor & Newton Series 7 watercolor brush. The best sizes are the No. 1 and the No. 2. Experiment to find the size that works for you. The advantage of a brush is that it gives you thin and thick lines without changing instruments. It gives your line a softer edge, and a brush line dries faster than a pen line. But the thing that the pros like about it is that it's fast. However, a brush takes time to master. Be sure to wash the ink out of your brush before it dries or it'll be ruined, and brushes are expensive. Just dab it in a jar of water immediately after using and dry it with a clean rag.

Professional inkers also use pens, which are easier to use than brushes. Starting out, you'll feel more confident using a flexible-point pen that has removable tips. There are many pen tips to choose from. Try starting with Joseph Gillott Nos. 170, 290, and 404. If your local art supply store doesn't carry this brand, ask the manager to help you choose something comparable.

Use a technical pen with a nontoxic ink to give you an even-weight line. Its points are interchangeable and come in varying degrees of thickness. It has a rigid feel. You should also buy a few nontoxic fine-line markers in different widths.

Use a nontoxic India ink for inking and Pro White for whiting out. If you use nonwaterproof ink, your drawing will smear if it gets wet after the ink has dried. Waterproof inks, on the other hand, are permanent.

French curves, available in many sizes and shapes, are used by pencilers and inkers for drawing smooth, curved lines.

Drawing circles and ellipses can take a long time if done freehand. So we cheat a little. We use circle and ellipse guides, which are plastic and translucent.

For inking straight lines, use a raised 6-inch plastic ruler. A T-square is too unwieldy to use for drawing short lines. Turn the ruler upside down and run your pen against the edge. If the pen weren't raised off the paper surface, the ink would blot, and you don't want that.

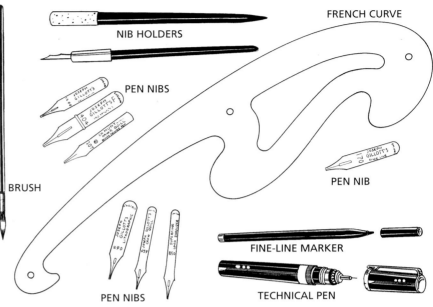

NIB HOLDERS

PEN NIBS

BRUSH

FRENCH CURVE

PEN NIB

PEN NIBS

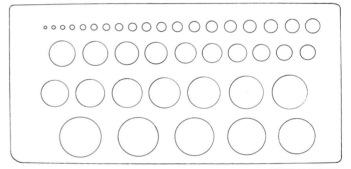

FINE-LINE MARKER

TECHNICAL PEN

CIRCLE GUIDE

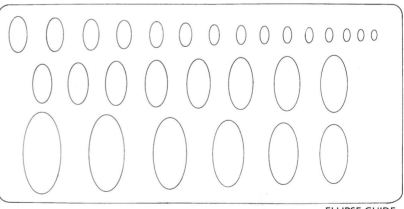

ELLIPSE GUIDE

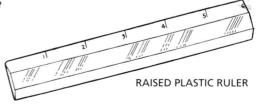

RAISED PLASTIC RULER

REFLECTIONS

Both glass and water reflect light. A glass skyscraper should be drawn so that it either reflects what's across the street, or so you can see through it, but not a combination of the two. Think of windows as a big sheet of glass interrupted by little strips of nonreflective material. Don't shade each pane differently. Also, be sure to show a slight rippling effect, which helps it to "read" as glass.

For the most part, water reflects the sky and surrounding foliage, depending, of course, on the character of its surface. If the water is smooth, it will reflect like a mirror. If it's rough or choppy, you'll get a broken reflection.

115

LIGHT SOURCE

Shadows can heighten the visual appeal of a character by making him or her seem more intense, more urgent. It also makes objects appear three-dimensional, because an object must have mass to cast a shadow.

But you can't determine where shadows go without first deciding where the light source is. What are some light sources? The sun is a light source. Lamps and street lights are light sources.

A partially opened window shade during the day is a light source. An explosion is an excellent light source, one so intense that it creates deep shadows.

Once you've decided on the direction and location of your light source, place your shadows *away* from it. Note that there may be more than one light source in a scene, and that they may differ in intensity. The brighter light source will cast shadows over the dimmer light source.

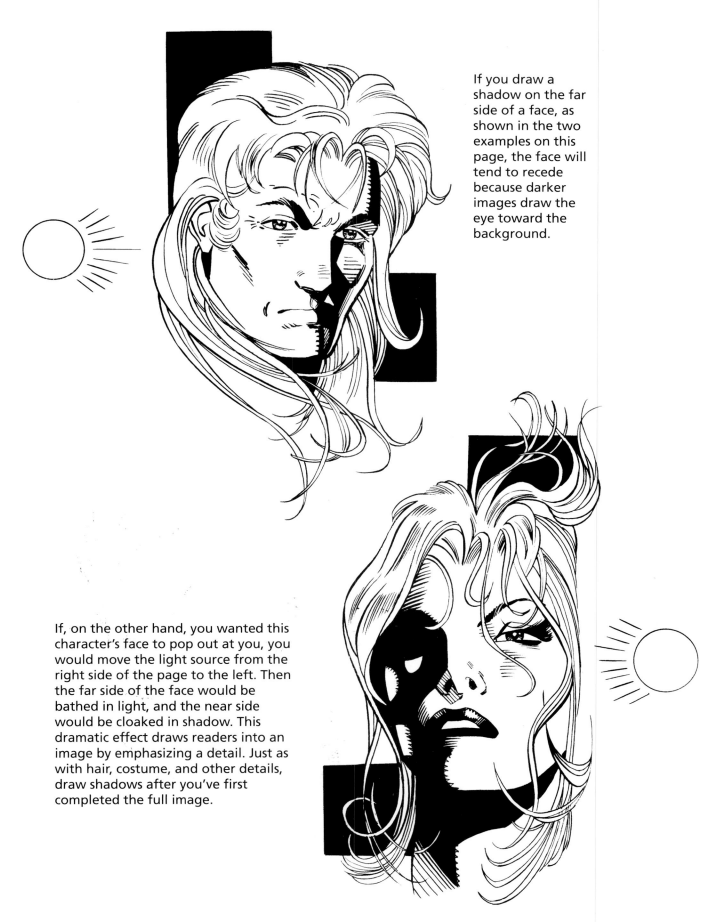

If you draw a shadow on the far side of a face, as shown in the two examples on this page, the face will tend to recede because darker images draw the eye toward the background.

If, on the other hand, you wanted this character's face to pop out at you, you would move the light source from the right side of the page to the left. Then the far side of the face would be bathed in light, and the near side would be cloaked in shadow. This dramatic effect draws readers into an image by emphasizing a detail. Just as with hair, costume, and other details, draw shadows after you've first completed the full image.

SHADING

There are several styles of modern comic book shading to choose from. Except for hollow shading, you can combine the techniques illustrated below according to your personal taste.

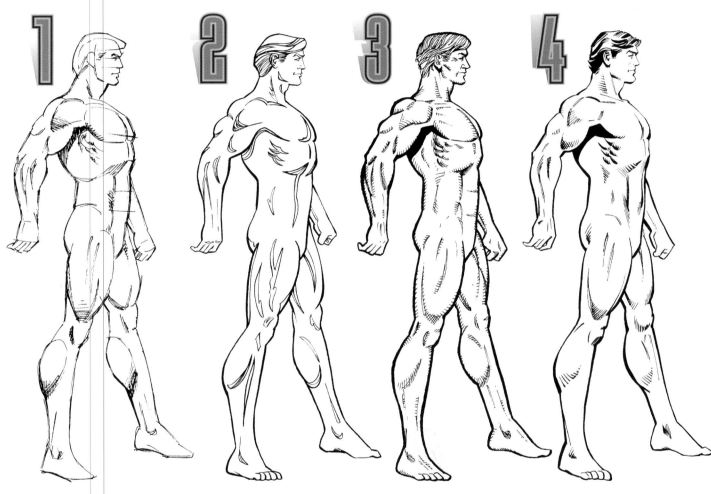

Here's the basic guy. (Even when relaxing, a comic book hero's muscles are always flexed!) The minimal shading here is loose and natural in appearance.

Hollow shading gives a reflective appearance. It makes the character look like he's made of plutonium. Notice that the shaded areas have sharp edges; they're not gentle pools of black shadow. This is a crisp, metallic, and severe look.

This is cross-hatching. It's more rugged-looking than the hollow style. This technique would work well on a down-in-the-trenches street fighter. A word of caution—this style can look too busy if you overdo it.

This is the standard comic book-style shading—old, reliable, and still as popular as ever. This approach combines light cross-hatching with pockets of solid black.

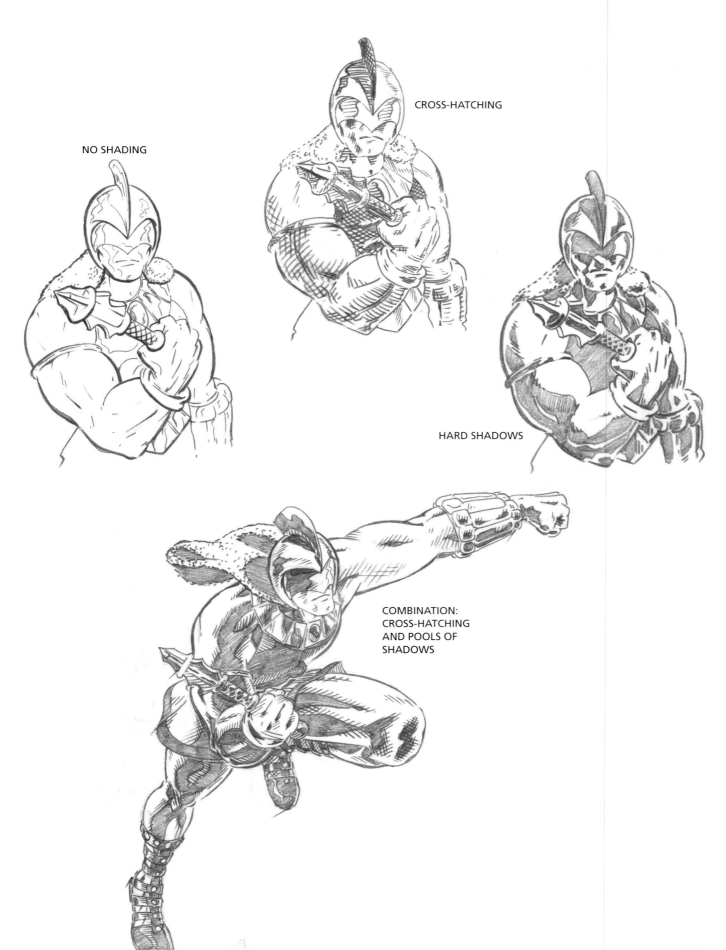

NO SHADING

CROSS-HATCHING

HARD SHADOWS

COMBINATION:
CROSS-HATCHING
AND POOLS OF
SHADOWS

VARYING AN INK LINE

The figure below, left, looks flat and dull. That's because it's drawn with only one thickness of line. So that your drawing has life, it's important to vary the thickness of a line. But you've got to have a plan. You can't just alternate thin and thick lines with no underlying purpose, because that would look weird.

The figure below, right, looks three dimensional. And there's some logic to it. If the source of light is above the figure, which is generally the case, the thinner lines are drawn toward the light, and the thicker ones are drawn away from it. More lines are usually apparent on the folds of the shaded side. The light source for the example below, right, is above and to the right of the figure. Can you see that? With the exception of heavy folds, the lines within a figure are lighter than the lines on its perimeter.

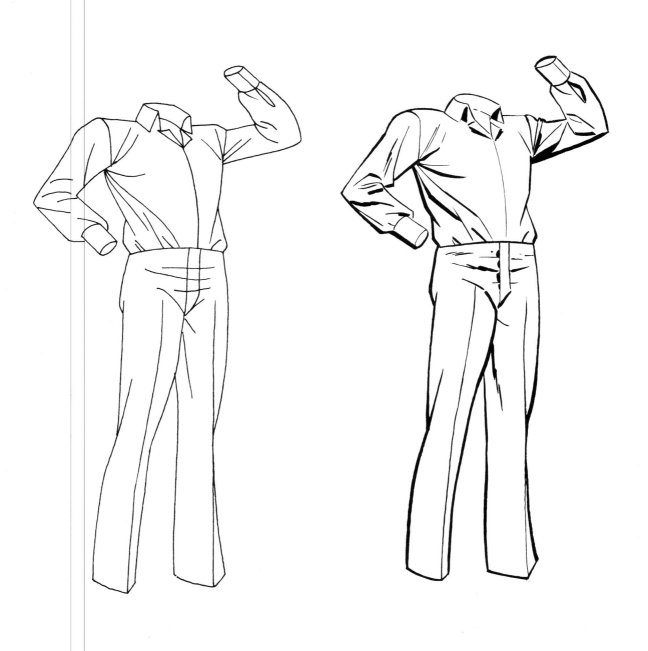

FOLDS AND DRAPERY

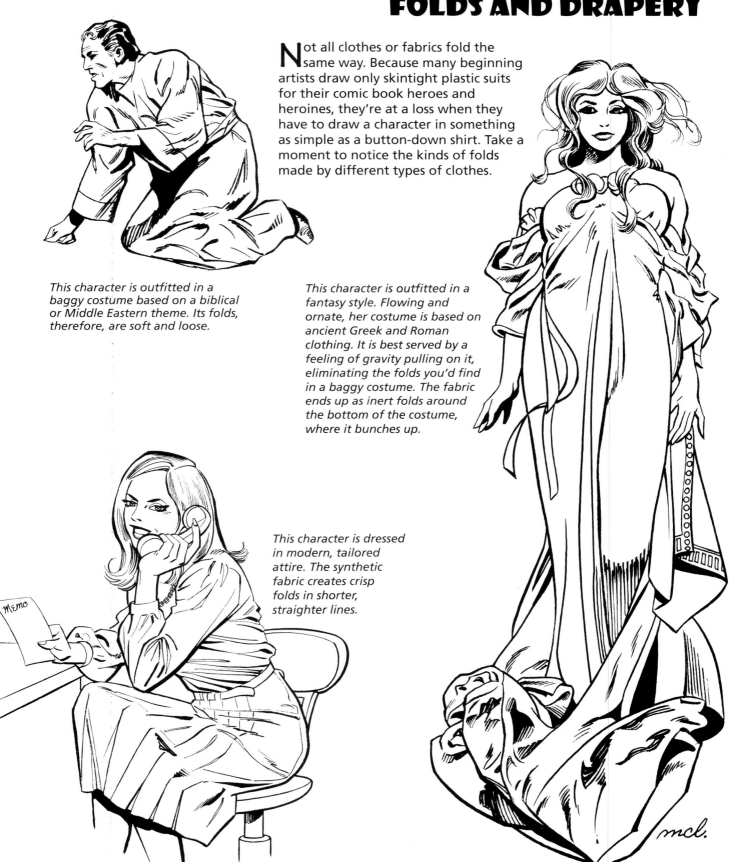

Not all clothes or fabrics fold the same way. Because many beginning artists draw only skintight plastic suits for their comic book heroes and heroines, they're at a loss when they have to draw a character in something as simple as a button-down shirt. Take a moment to notice the kinds of folds made by different types of clothes.

This character is outfitted in a baggy costume based on a biblical or Middle Eastern theme. Its folds, therefore, are soft and loose.

This character is outfitted in a fantasy style. Flowing and ornate, her costume is based on ancient Greek and Roman clothing. It is best served by a feeling of gravity pulling on it, eliminating the folds you'd find in a baggy costume. The fabric ends up as inert folds around the bottom of the costume, where it bunches up.

This character is dressed in modern, tailored attire. The synthetic fabric creates crisp folds in shorter, straighter lines.

MEMO

mcl.

DESIGNING COSTUMES

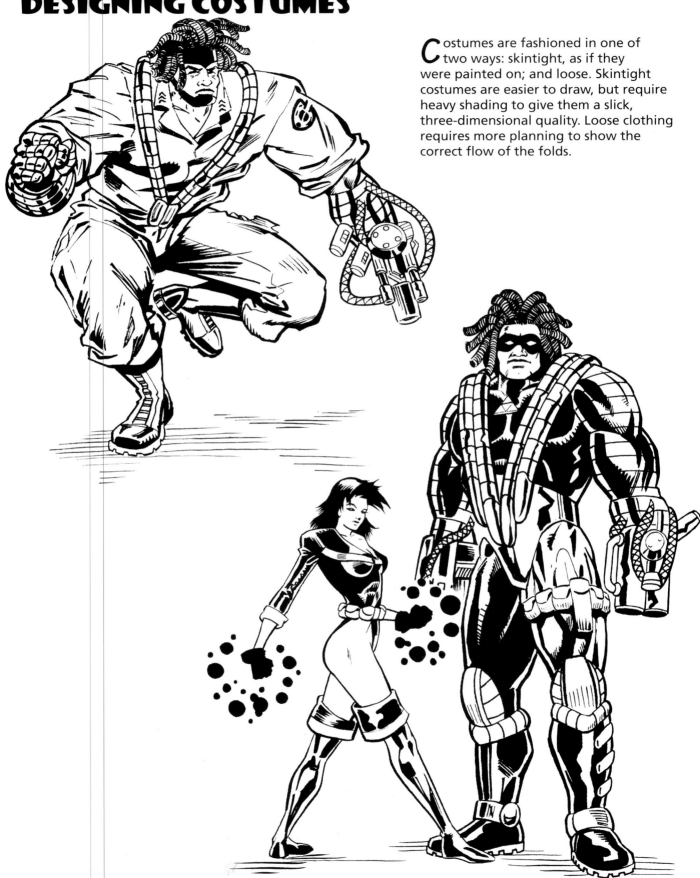

Costumes are fashioned in one of two ways: skintight, as if they were painted on; and loose. Skintight costumes are easier to draw, but require heavy shading to give them a slick, three-dimensional quality. Loose clothing requires more planning to show the correct flow of the folds.

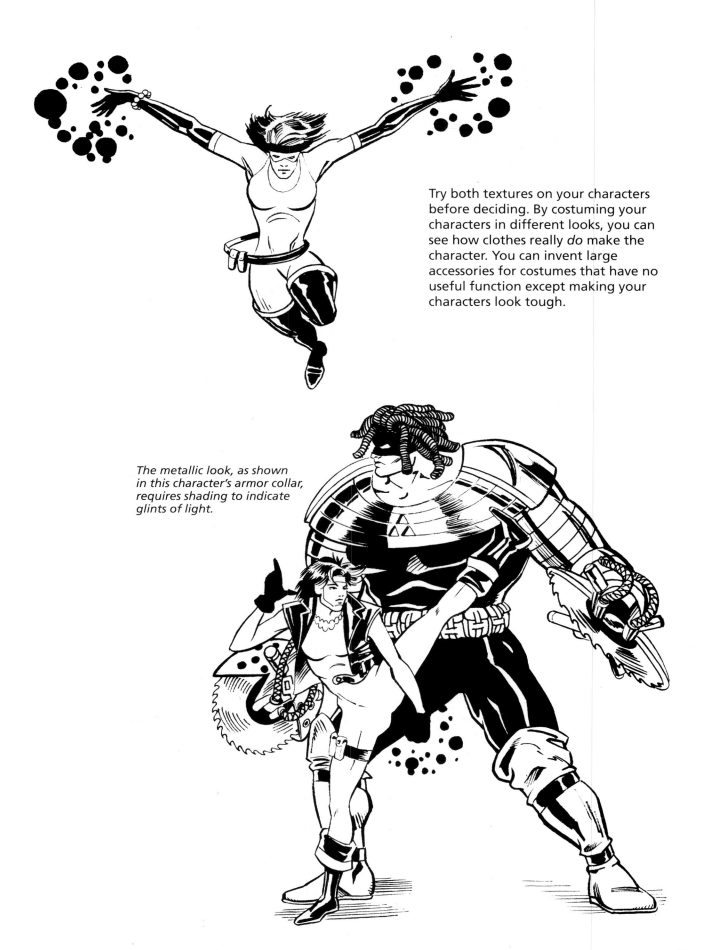

Try both textures on your characters before deciding. By costuming your characters in different looks, you can see how clothes really *do* make the character. You can invent large accessories for costumes that have no useful function except making your characters look tough.

The metallic look, as shown in this character's armor collar, requires shading to indicate glints of light.

FIRE POWER

WEAPONS HAVE ALWAYS BEEN POPULAR comic book props, since they heighten the stakes in a story. If one character has a serious weapon, then the motivation for winning—and the fear of losing—is much greater. Whoever holds the bigger weapon takes on the role of the hunter, while the character who is out-gunned becomes the prey. If two characters have equally powerful weapons, the city will be annihilated during a shattering fight scene.

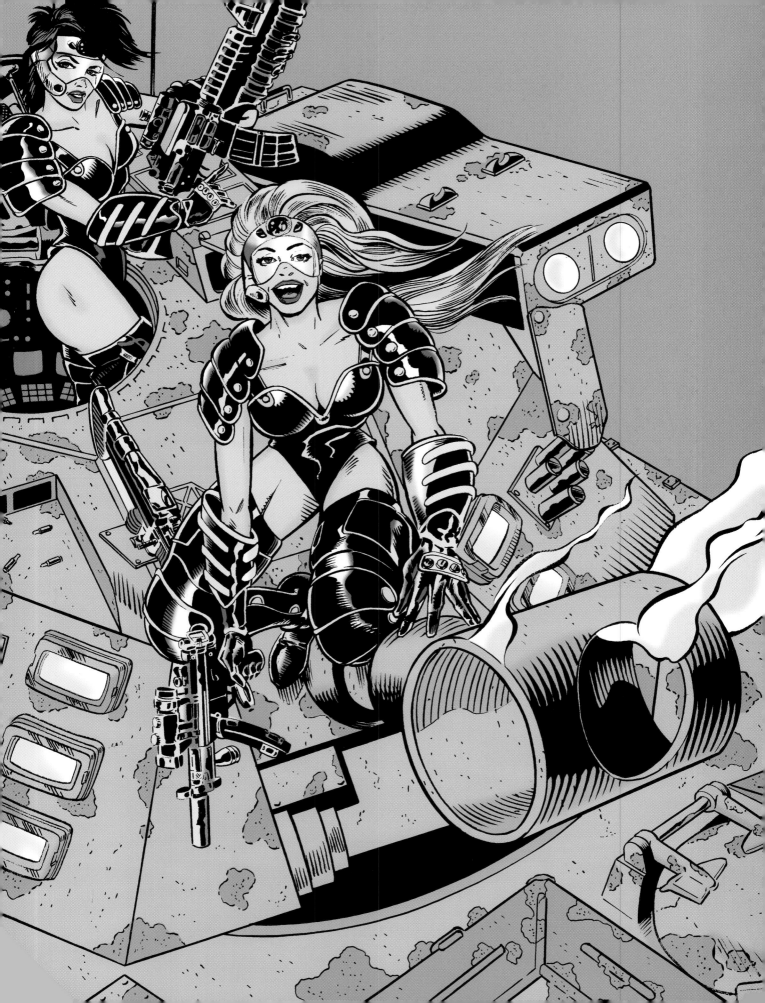

RAPID FIRE

When drawing any weapon, the method is the same. Start with rectangular shapes, combine them until the general outline of the entire weapon becomes recognizable, then blend them together. Then go to work on the fun stuff, and put on all the bells and whistles.

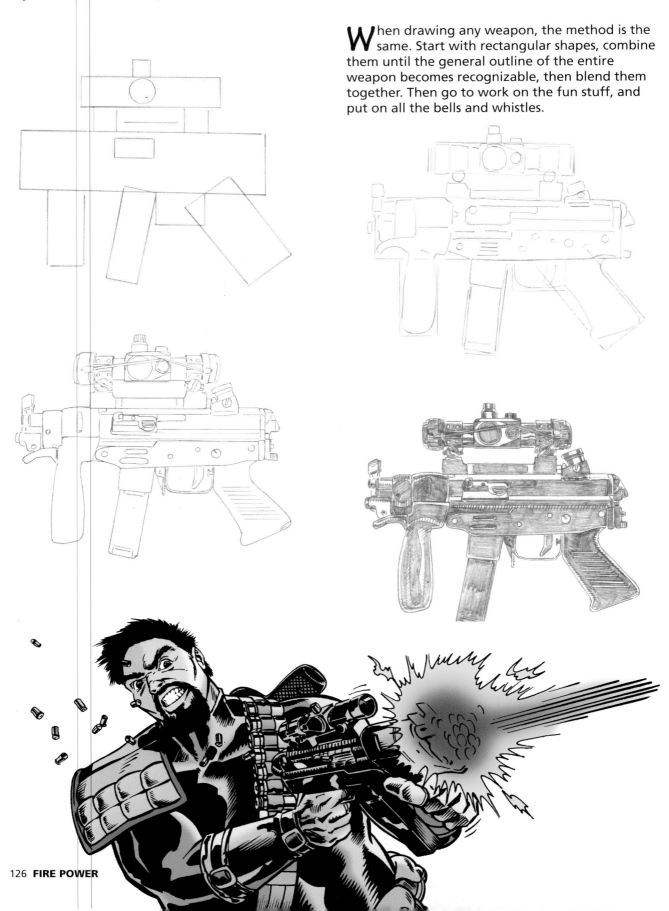

IN THE CROSSHAIRS

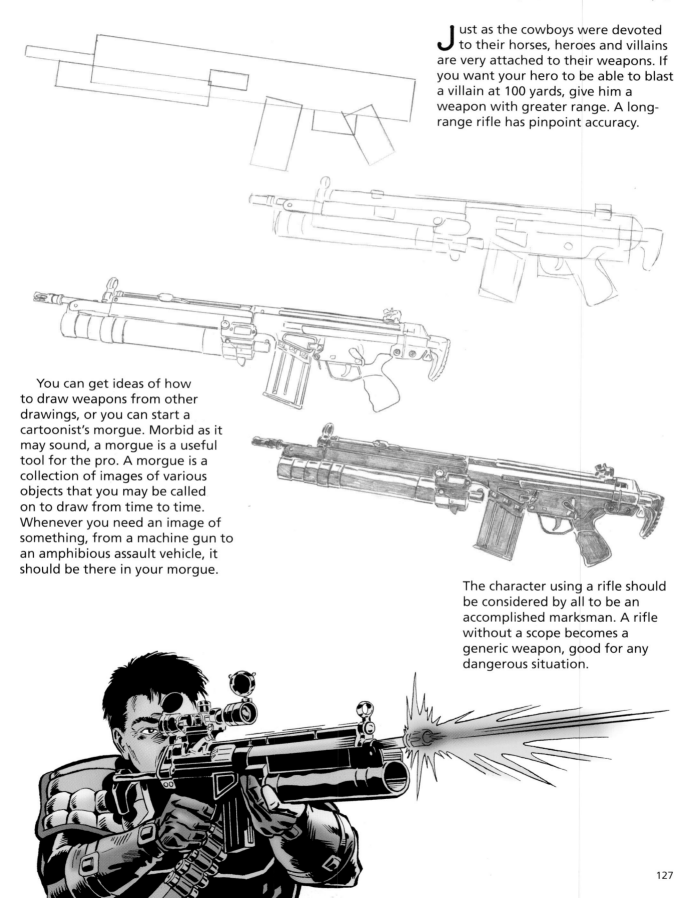

Just as the cowboys were devoted to their horses, heroes and villains are very attached to their weapons. If you want your hero to be able to blast a villain at 100 yards, give him a weapon with greater range. A long-range rifle has pinpoint accuracy.

You can get ideas of how to draw weapons from other drawings, or you can start a cartoonist's morgue. Morbid as it may sound, a morgue is a useful tool for the pro. A morgue is a collection of images of various objects that you may be called on to draw from time to time. Whenever you need an image of something, from a machine gun to an amphibious assault vehicle, it should be there in your morgue.

The character using a rifle should be considered by all to be an accomplished marksman. A rifle without a scope becomes a generic weapon, good for any dangerous situation.

HIDDEN DANGER

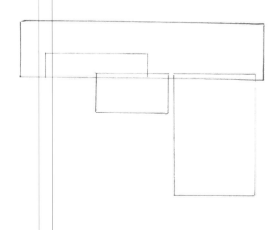

In a pinch, when your hero is cornered, out of luck, and has nowhere to turn, he just may be hiding a pistol under a pant leg. Small, but deadly, the pistol is a great last-ditch weapon.

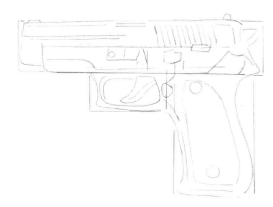

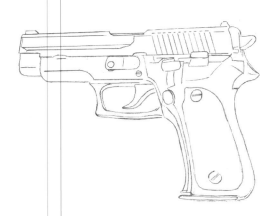

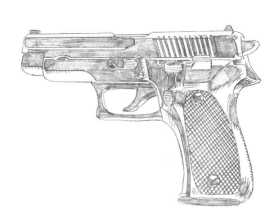

Spent cartridges fly off as a gun fires, which is indicated by a burst. A double image of the gun shows its kick.

Smoke rises delicately from a gun that has just been fired.

AGGRESSIVE ASSAULT VEHICLES

Not all heroes can fly. But when duty calls, your hero can't very well buy a ticket on Amtrack. So how does he get from here to there? In a high-tech, fortified, ground assault vehicle. Some comic book vehicles, like the Batmobile, have become so famous they are almost characters in and of themselves.

The vehicles should look convincing and state of the art, fully armed with a variety of weapons. One look at an assault vehicle should send chills through the enemy camp. A comic book hero in an assault vehicle would have no compunction about driving right through the window of a restaurant if a bad guy were inside.

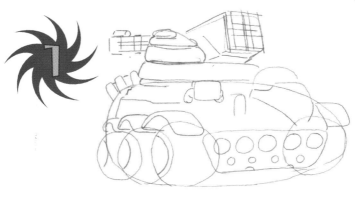

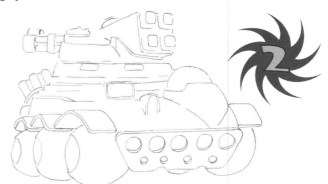

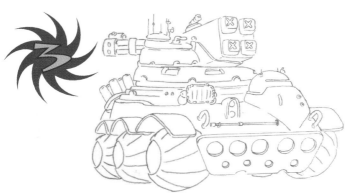

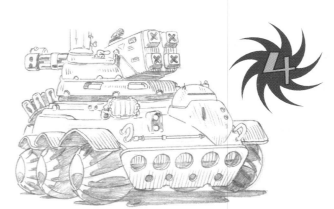

Alexander Morrissey can draw military vehicles as well as anybody in the comic book field today. Notice how he achieves his results:

1. Start by outlining the large shapes. Sketch in huge, knobby tires that will allow the vehicle to drive over literally anything. The key is to overlap the tires. Add protruding forms such as guns and fenders. Begin to sketch in the design of the vehicle's body.

2. Refine the forms to give them dimension. Sketch in some details, but keep the drawing loose. You can clearly see the complex layers that make up this type of tank.

3. Now for the fun stuff: tire treads, weapon systems designs, buttons, hatches, and radar.

4. Add the correct shading.

5. Finish up by inking.

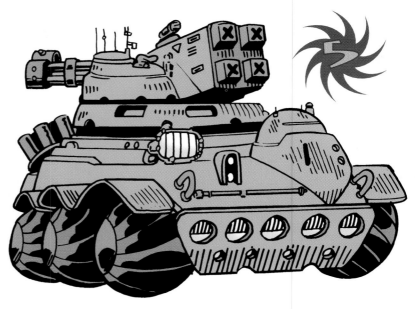

OFF-ROAD

Even heroes without super powers, such as a band of teenagers, can become exciting characters in a comic book. But they need to be given the tools to fight crime. An off-road truck can help accomplish this. An off-road truck should have huge tires, a souped-up chassis, and heavy-duty fenders, perfect for ramming. This kind of vehicle gives the reader the sense that its driver is ready for action, that he or she can and will go anywhere the action is taking place.

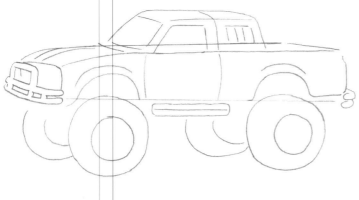

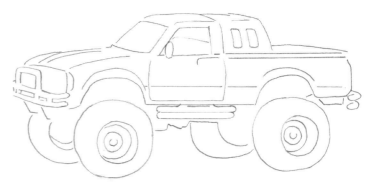

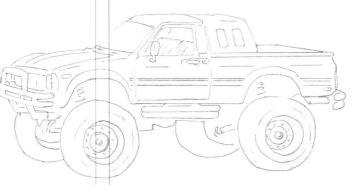

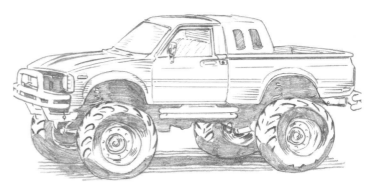

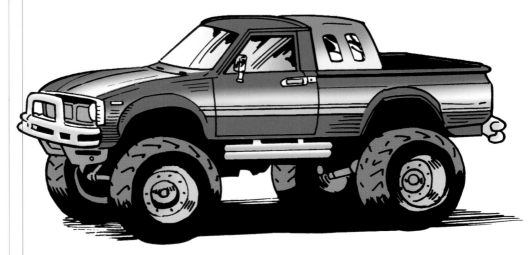

Motorcycles convey a feeling of speed, power, and freedom, and embellish a character's personality. After all, Clark Kent never rode a hog. What your character rides says a lot about who he or she is. A motorcycle also allows the reader to see the character's body while he or she is driving. In a car, the character is mostly hidden from view.

Give your hero's bike a beefed-up look that's built for speed. A motorcycle is exciting because of the way it can weave between pedestrians on side-walks and make impossible jumps over open drawbridges.

SKY PATROL

Great chase scenes can be created when you combine two entirely different modes of transportation; for example, a helicopter chasing a motorcycle. The two vehicles have different strengths and weaknesses, and just as with superheroes, the weaknesses are as important to the drama of the chase as the strengths.

For instance, the chopper's strength is immediately apparent: It can fly faster and has a greater capacity for spotting a target. The chopper might also be equipped with guns. The pilot has a radio that he can use to call for backup. The chopper's weakness is chilling: It might have to fly dangerously low to follow the motorcycle and get sandwiched between two tall skyscrapers. Splat city.

The motorcycle's advantage is that it can drive through places like tunnels, buildings, and malls that the helicopter can't. It's easy for the driver to ditch his motorcycle, but not so easy for a chopper pilot to get out of his chopper whenever he feels like it. The motorcycle's potential drawbacks are oil slicks, traffic jams, crashes, and police cars that enter the fray as the motorcycle whizzes by at 100 m.p.h. or more.

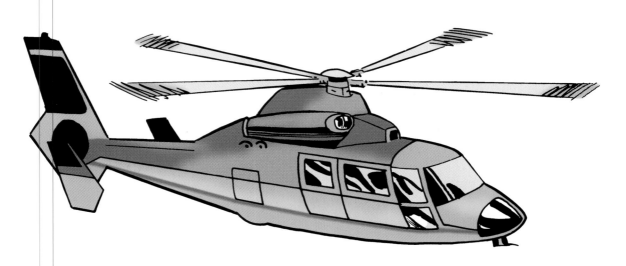

When you want to blow something up—and who among us hasn't had that desire at one time or another?—then it's time to send in the fighter aircraft.

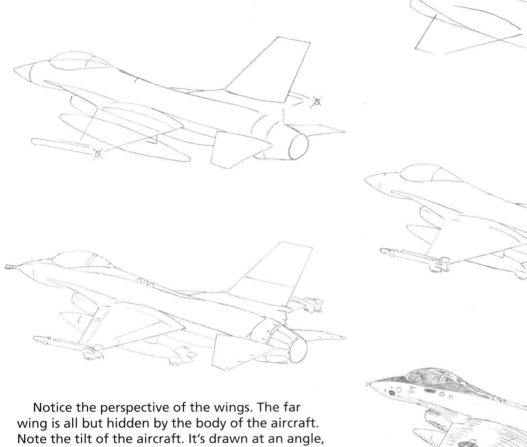

Notice the perspective of the wings. The far wing is all but hidden by the body of the aircraft. Note the tilt of the aircraft. It's drawn at an angle, as if it were ascending. A horizontal view would be much less interesting. Also, its weapons are in full view. An aircraft doesn't need to have a lot of gizmos drawn on it. Its high-tech look is implied by the graceful lines of its form; for example, in the way its nose tilts downward in an aggressive posture.

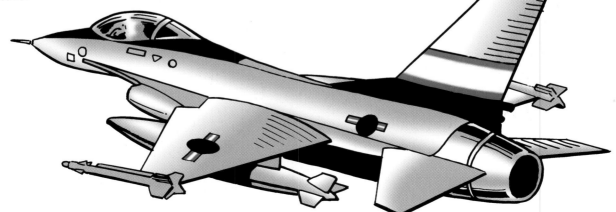

MAKING IT IN THE BIZ

SO YOU WANT THE INSIDE STORY on how the comic book biz works? Smart thinking. You'll need to know what happens in the real world so that you won't be lost when you get your first job. You've come to the right place. Keep reading, because here is the inside, professional scoop.

HOW THINGS ARE SUPPOSED TO GET DONE

Putting together a comic book is a big job. Many talented people—and maybe a few not-so-talented ones—are involved in producing it. What follows is a step-by-step chronology of the birth of a comic book issue. Take note that there are job titles listed here that you may not have considered for yourself but that may appeal to you, such as writer, editor, or computer colorist.

1. THE EDITOR has a deadline to deliver a new comic book issue, so he quickly calls—

2. THE WRITER, who writes the story and dialogue and indicates the action. The script is then sent to—

9. THE COMPUTER COLORIST, who puts in all those nifty tints we love so much. The colorist gives it right back to—

8. THE EDITOR, who checks it again, and then fires it off to—

10. THE EDITOR, and this is the last time he can make any changes. If he says the word, it gets shipped to—

11. THE PRINTER who's about as exciting a guy as your uncle in the men's wear business. Meanwhile, back at Comic Book Headquarters, they're having a—

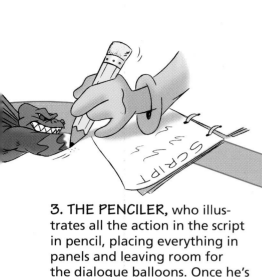

4. THE EDITOR for his approval, and if he likes the pencils, he shoots it over to—

3. THE PENCILER, who illustrates all the action in the script in pencil, placing everything in panels and leaving room for the dialogue balloons. Once he's done, it goes quickly back to—

5. THE LETTERER, who letters the dialogue in ink, and then gives it to (guess)—

7. THE INKER. By now everything is usually running behind schedule. The inker inks the book and erases the pencil lines, then hands it back to—

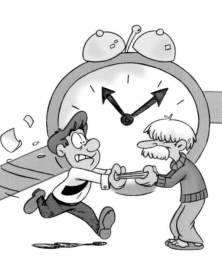

6. THE EDITOR, who checks the details. Then it's on to—

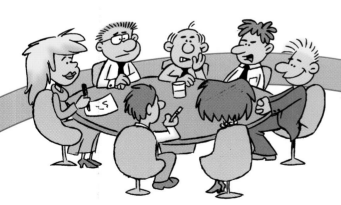

12. COVER CONFERENCE. The executives are trying to decide what the cover should look like, and when they can break for lunch. A different artist does the covers because the publisher wants all their covers to have a similar look. Once that's decided, it's time to do it all over again with another issue. So what happens to the original artwork? It goes back to—

13. THE ARTISTS, and gets divided between the penciler and the inker, for them to keep, frame, or sell.

HOW TO GET YOUR FIRST JOB

You're already on the right track. You're drawing and educating yourself with this book, while other guys are at the beach, preparing themselves for the future by deciding what number sunblock they should use.

The next thing you might want to consider is getting an art education, by attending classes at an art school, continuing ed, or the university you're enrolled in. In art school, you'll be inspired by your classmates. You'll strive to increase your ability because you'll want to keep up with everybody, or be just a little better than they are. Take classes in drawing, perspective, design, and anything else that interests you, but don't focus solely on what type of class to take. Look for the instructors who have the most to say and can challenge you. If an instructor loves everything you do and thinks that art is self-expression—and that therefore no one should judge anyone else's work—run the other way. Everyone judges everyone else's work—that's how you get hired, because your work is better than the next guy's.

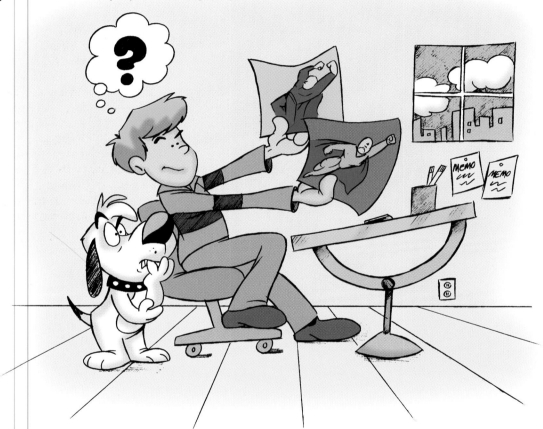

ORGANIZING A PORTFOLIO

If you're going to convince someone to hire you, you've got to show them your stuff. One way to make a portfolio is to collect copies of your best drawings (never include original art in a portfolio because you may be asked to leave it behind for review) and arrange them in a nice-looking carrying case that you can buy at an art store. The largest size an individual piece of art should is 11 by 14 inches, and the smallest is 8½ by 11 inches. Show between ten and twenty pages, and include color pieces if you have them.

To prepare a portfolio that is more specific to the comic book field, try revamping a character that a comic book publisher already owns. Don't use a superstar character like Superman, but someone less popular that has been lying dormant for a few years. Create a whole new approach for the character. Write a two-page story synopsis and reinvent the costume and supporting characters. But don't reinvent any popular characters with whom the character interacts (no editor wants to reinvent something that's working). This type of portfolio shows the editor that you can draw *his* characters, which is what he wants. In addition, if you can bring new life to a tired formula, you might be the answer to an editor's prayers.

MEETING THE PUBLISHER

Once you have your portfolio together, you can try calling the publisher for an appointment to show your stuff. But it's not always easy getting through.

If you can't arrange for a meeting, send a copy of your portfolio with a cover letter and a self-addressed stamped envelope. You can get the publisher's name and address by looking at the small type at the bottom of the first page of a comic book. If you do get to meet with a publisher, or with someone else at the company, make sure you leave something behind that is representative of your best work.

DOING YOUR HOMEWORK

By visiting a comic book store and combing through new and obscure issues, you can find smaller comic book publishers that may be willing to take a chance on you. But most important, you'll get the latest info at a comic book shop. Everyone there is a fan. And every fan knows a comic book artist or two. You can make connections. But while you're in there, be sure to find out where the next comic book convention is being held. That's where the action is.

COMIC BOOK CONVENTIONS

There are always pros roaming the conventions, so bring your portfolio. Many comic book publishers set up booths at conventions to interview new artists. You want to find a pro who needs an assistant. Try to show your stuff and see if you can get phone numbers. Then be sure to call after the convention is over. Don't expect a pro to call you. He's got a job. You're the person who wants one.

APPRENTICING

Once you're apprenticing for a pro, you can pester him with all the questions you've ever had, and he'll probably answer them. When he gets busy, he'll start to throw smaller jobs your way, and maybe he'll even help you to set up your own studio.

As you improve, you'll graduate from backgrounds to more impressive stuff. Then one day, as you're roaming a comic book convention, some kid will walk up to you and ask you to look at his portfolio. And you'll realize that you're so busy, *you* need an assistant to do *your* backgrounds.

When that happens, you've arrived.

INTERVIEW WITH A NOTED COMIC BOOK EDITOR AND PUBLISHER

OH GREAT COMIC BOOK MASTER-- WHAT IS THE ANSWER?

As an editor at Marvel Comics, Jim Salicrup presided over such famous titles as *The X-Men, The Fantastic Four, Captain America, Iron Man, Thor,* and many others. He left Marvel to become the associate publisher and editor-in-chief of Topps Comics, where he has ushered in the successful comic book titles *Bram Stoker's Dracula, Jurassic Park, Duck Man, Mars Attacks,* and *Zorro.* Jim shares with us his views on the origins of comic books, where they're headed, and some of the opportunities available to the aspiring comic book artist today.

Hart: Jim, what makes a great penciler?
Salicrup: Each case is different. You could take someone I think is a brilliant penciler, a dark superhero avenger-type artist, and you give them a romance story that's supposed to be nice, bright, innocent, and light, and they make it seem like a Martin Scorsese film—that might be interesting but it may not be what you're looking for. So it always depends on the project. If you have a western, obviously it helps to find an artist who, number one, is very passionate about that period.

Hart: Can you comment on the traps beginning artists tend to fall into?
Salicrup: When they get their first script, it's a strange phenomenon. They almost look at it the way my daughter looks at her homework assignment—the priority is to get it done. I mean, they have that deadline looming over them, and they want to get their paycheck—all that I can understand. And if the script says, "the hero's looking out the window, then he talks to his best friend, then he makes a phone call," beginners could say that the story is just dull—there's no fighting, no action—and they'll just draw the first thing that pops into their heads. And I'll have a dull page. And if I say that it doesn't look as exciting as I thought it would, they'll immediately blame the writer: "Well, what do you want me to do? This is a dull script. Give me something exciting to draw."

And to me that's not really an acceptable response. The top artists in the business could make a splash page out of that. They could have this breathtaking cityscape. They could have other things going on that are totally fascinating, and you pull back, and the hero is talking to his friend. And there's a way to do a sequence where making that phone call is a turning point in the story, and the way that the characters move, and their responses, and the way that the frames are cut and the panels are designed—suddenly this phone call is as important as any fight.

Hart: Can artists today hope to own their own characters? I know that in the past that was impossible. The guys who invented Superman were cut out of the whole thing.

Salicrup: It's a tricky thing. Siegel and Shuster [the creators of Superman] are a good example, in the sense that their undoing was not so much the "evil publishers"—although I'm not going to defend the publisher's actions in this case—but their sheer frustration. They had a character that they were really excited about. They tried for years—I believe it was about five years—to sell it, and it's something that they really felt strongly about. Just to see it in print, and at that point as a comic book, meant so much to them that they were willing to sign almost any deal. And the same thing could happen today. It happens a lot with creative people. If they have a passion for something, whether it's to star in a movie or sign a recording contract, they have to be very careful about the kind of deal they make. A lot of creators may feel, "Well, this is just one of my characters. I'll give that one away, but the next one I'll own."

Hart: And there never was another Superman.
Salicrup: The environment has changed a lot for the better. There are more cases today where people publish their own work and make better deals with publishers to retain all sorts of rights. And even if artists are creating characters for comic book companies, they could make better deals than have ever been made before. When I started twenty years ago, a lot of those options were the stuff dreams were made of. It wasn't as easy as it is today.

Hart: Would you recommend art school to someone who wants to be in this field? Do you think a formal education in art is beneficial?
Salicrup: Definitely, but it's not essential. There have been a lot of great comic book artists that were totally self-taught. It's like any great talent: If the ability's there, education will hone it and make it better, perhaps. If someone doesn't have the talent, but has the money to take classes, it could be a sad thing to look at that graduate's work. It may be lacking some kind of spark. But what tends to be the best part of attending an art class or a school is seeing real artists, either instructors or guest lecturers. Once the student starts in anything that resembles a real situation where he or she has to create comic books, that experience can be really beneficial, as opposed to just working in your basement.

Hart: How have women's roles as comic book heroines changed through the years?
Salicrup: It tends to reflect what's going on in society in general. In the early 1960s, probably the most telling example of this was the female character in *The Fantastic Four.* She was called the "Invisible Girl"—someone you don't see. And she's not a woman, she's a girl. She's the girlfriend. She's the sister. Her powers are to fade away. Often what happens in pop culture is that one stereotype is replaced by the latest, newer stereotype. So now you get a lot of sexy, aggressive, powerful female characters.

Hart: Do you have any advice for aspiring comic book artists?
Salicrup: When I review portfolios, I tell artists that they should show me what they truly think they're best at and most passionate about. Although "What are you looking for?" is a very valid question, sometimes I may not know what our next project is going to be. If an artist feels he's the best at funny animal cartoons, or moody atmospheric pieces, or whatever, the best tip I could give is to include a couple of pages that represent what he would really want to do under ideal circumstances. Chances are that the work might be a lot better than his samples of the top company's popular superheroes and typical action and talking pages. If he could really show me something that makes him unique, that he's the only guy who can do this kind of work, that has a far more lasting impression on me than if he gives me something that's kind of generic and looks like what everyone else has shown me.

Try to find out as much about the field as possible. This can be done just by visiting the local comic book shop, finding out everything about every detail. The more you know, the better you'll be able to figure out what your next step is, whether it's presenting artwork to publishers, contacting writers directly, perhaps writing and publishing your own comics, whatever is best for you. The more you find out about the field, the more informed your decisions will be.

INDEX